Photo craft 14462
Johns, Susie 745.54 JOH

DATE DUE

MAY 6 1998	
DEC 1 9 1998	
AUG 1 1 2004	
OCT 2 1 2004	
JUN 1 9 2005	
JUL 2 0 2006	

BRODART, CO. Cat. No. 23-221-003

For my father

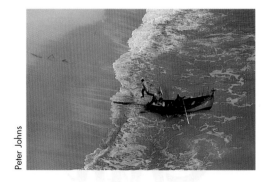

Peter Johns

First published in the United States in 1998
by Amphoto Books, a division of
BPI Communications, Inc.,
1515 Broadway, New York, NY 10036

Copyright © Susie Johns, 1997

Design and Art Direction by Desmond Curran
Photography by Amanda Heywood, Edward Allwright, Di Lewis
and Susie Johns

This book has been produced by Aurum Press Limited,
25 Bedford Avenue,
London WC1B 3AT

ISBN: 0 – 8174 – 5428 – 4

Printed in Hong Kong by Paramount

Photo Craft

50 CREATIVE IDEAS FOR USING PHOTOGRAPHS

SUSIE JOHNS

AMPHOTO BOOKS

an imprint of Watson-Guptill Publications/New York

Contents

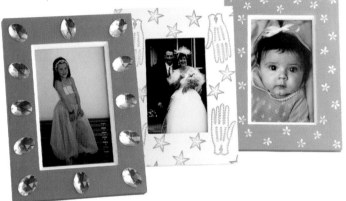

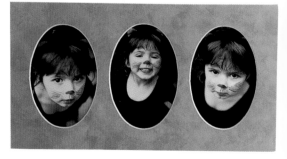

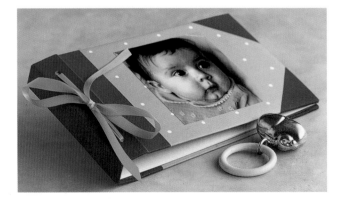

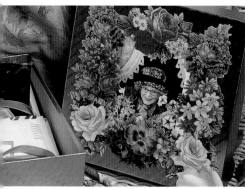

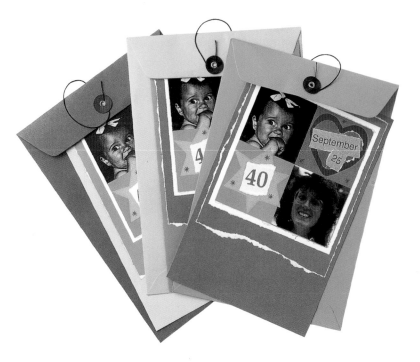

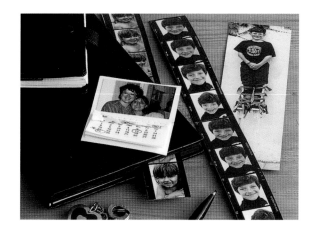

Introduction

Why go to the trouble and expense of buying film, putting it in your camera, taking pictures, having the film developed and printed – only to stick the resulting photographs in a drawer! If you haven't done so before, now is the time to open up that drawer and start sorting out your photographs.

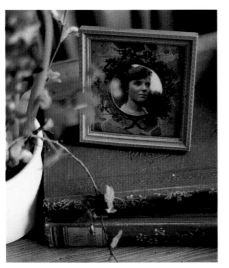

Choose a few favourites and stick them up straight away – on a pinboard or on the fridge door. Now divide your remaining prints into various categories, ready to frame, to put into albums or to make some of the other projects in this book.

Be ruthless and throw away any real failures or chop them up and make them into mosaics, like the frame on page 52 – and resolve to improve your picture-taking the very next time you pick up your camera.

Taking pictures

Most people take pictures of people: babies, children, friends and family members. Cameras are taken along to weddings and parties, and are essential for keeping a record of holidays, days out and special events.

Each time you press the shutter release button you create a memory – corny but true. By recording that moment on film you freeze time and the resulting photograph is a permanent reminder, a souvenir, a memento.

We are lucky that technology has given us the means to create these visual records – and so quickly and easily. In the 1830s, when Henry Fox Talbot made the first photographic images, exposure times could be anything from 30 to 90 minutes; now we take pictures in a split second.

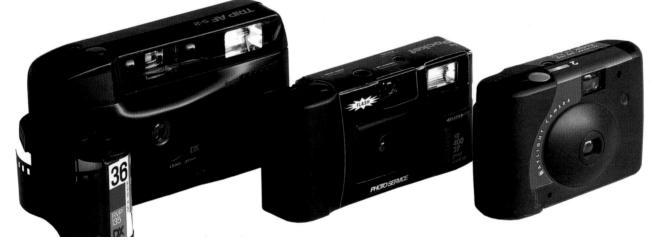

Perhaps because it is easy to produce a picture, we are too carefree about pressing that button. Compact cameras, the type most people use, are known as 'point and shoot'. Technical decision-making has been removed but remember, it's the photographer, not the camera, who takes the picture.

Taking photographs can be a hit or miss affair unless you take time to consider such things as lighting, composition and content before you shoot. It will be worth it. We all know how satisfying it can be when, among the batch of prints we pick up from the processors, there are some really good ones: pictures that are well-composed and pleasing to the eye.

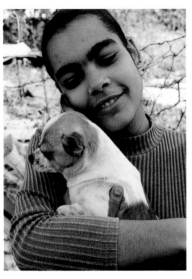

Some picture-taking techniques, including lighting and composition, are covered at the end of this book. The rest of the pages are filled with ideas for using the photographs themselves. If you take a picture you are proud of, why not show it off? All the projects are easy and relatively quick and you will need no special materials or skills to achieve good results.

Some projects are so easy to do that no special instructions are given, just descriptions and ideas to get you started, and photographs of finished items to inspire you. Where necessary, however, making-up is explained in detail, with step-by-step pictures and lists of materials and equipment needed. The photographs themselves are not usually included in the list, as photographs

are the linking theme for all the projects in this book.

If you need more than one copy of a picture to complete your chosen projects, it is easy to have extra prints made from the negative. If you have lost the negative, do not despair, as many processors can make duplicates from the print itself. Many of the projects also utilise photocopies: look out for high street copy shops or stationers that offer a colour photocopying service.

Materials and Equipment

Most of the projects in this book use materials that you will already have in the house, such as cardboard, paper, fabric and, of course, photographic prints. Use white or coloured mounting cardboard for decorative mounts but for cardboard-based projects where the cardboard is to be covered, inexpensive grey board or cardboard recycled from boxes or the backs of writing pads is fine. Wrapping paper or wallpaper can be used for covering albums, but paper-backed fabric, bookbinder's linen and carpet tape give a more professional finish.

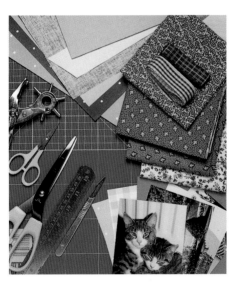

A supply of old newspapers and rags is invaluable for protecting your work surface from glue and paint.

Cutting

You will need a craft knife and steel ruler for trimming prints, and a board or cutting mat. An ordinary paper punch is useful for making holes in paper and thin cardboard but for thicker cardboard, invest in a heavy-duty punch. Small pointed scissors are essential for cutting intricate shapes from paper.

Gluing and sticking

PVA (polyvinyl acetate) or white glue is strong enough to glue thick cardboard and can be diluted and used for découpage and as a sealant on bare wood. Opaque when applied, it becomes transparent when dry. A glue stick is perfect for sticking prints on to a backing cardboard for framing, and safe enough for children to use. An all-purpose glue will stick fabric, cardboard and paper.

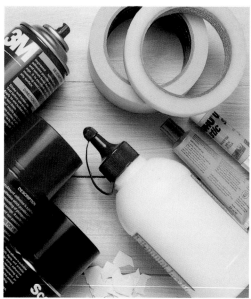

Spray adhesives, specially designed for mounting photographs, are quick and easy to apply. For a temporary display, choose a non-permanent spray that allows for repositioning. Masking tape is also useful, for holding pictures in place while glue dries, or for masking off areas when painting. Double-sided tape is sticky on both sides.

Simply cut a piece the length you require and stick it on to one surface, remove the paper backing and press in position. It's a good, no-mess method of fixing pictures permanently into an album. To avoid damaging photographs, however, choose traditional photo corners.

Painting

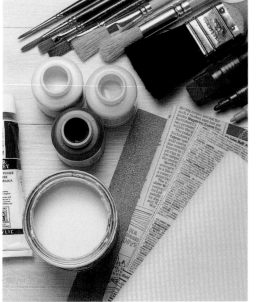

Bare wood should be painted with a coat of primer before any decorative paintwork is applied. Gesso gives a smooth, opaque surface but you can also make do with household flat latex paint. For painting small items, use artists' acrylic paints, available in tubes, which can be thinned with water, or craft paint, which is also water-based and comes in pots in a range of finishes such as gloss, metallic or pearl.

For painting on wood, choose artists' brushes with synthetic bristles; use an old brush for applying PVA; for painting on paper or cardboard use finer brushes with natural sable or squirrel hair, or synthetic substitutes. Look out, too, for poster colour markers: paint-filled pens that are quick and easy to use.

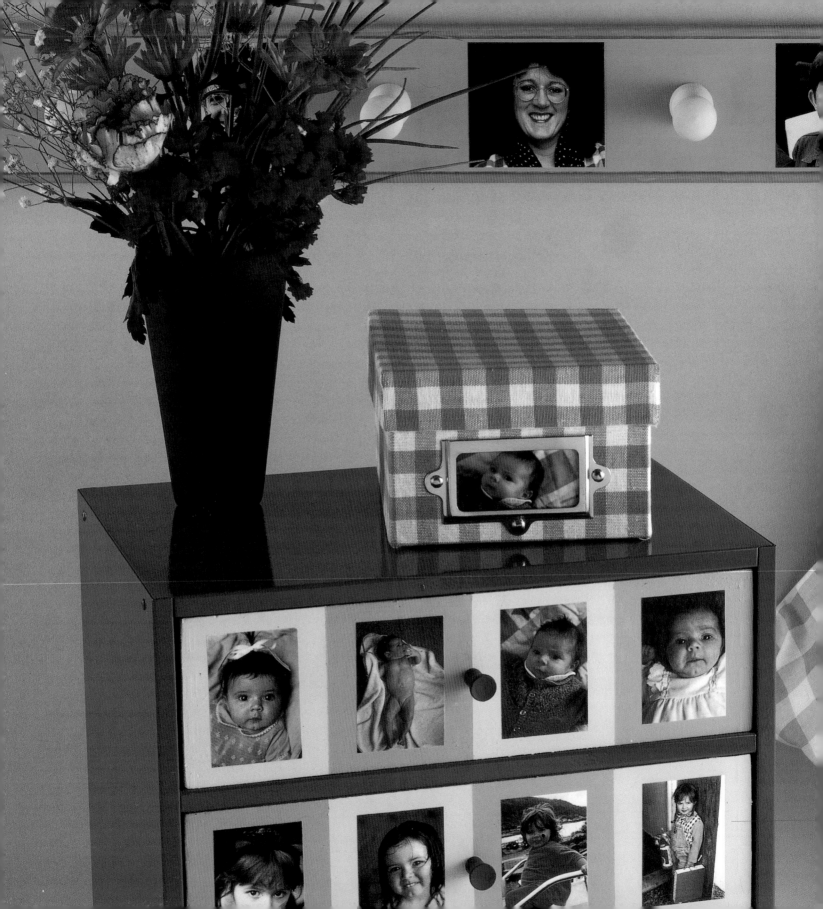

Decorating Ideas

Proudly display your prized photographs around the home, using pictures purely as decoration or as a way of labelling your property.

Photo Storage Boxes

With attractive boxes in which to store your treasured pictures, you will be happy to keep them organized.

A humble shoe box can easily be transformed into stylish – and practical – storage for your photographs. In fact, shoe boxes are usually just the right size for prints.

Repair and reinforce your box with gummed paper tape, if necessary, before covering it with paper or fabric. When you have filled your box with photos, stick a sample picture on the outside of the box, as a clue to its contents.

For a professional touch, add a brass label holder, available from hardware stores, secured with brass paper fasteners. Then slot in a picture cut to size.

BOXES CAN BE COVERED WITH FABRIC TO MATCH THE FURNISHINGS IN YOUR ROOM.

Materials & Equipment

shoe box
fabric or paper
PVA glue
brass label holder
brass paper fasteners
pencil
ruler
scissors

1 Cut your fabric or paper to size. To do this, first stand the box in the centre of the wrong side of your covering material and draw around the base.

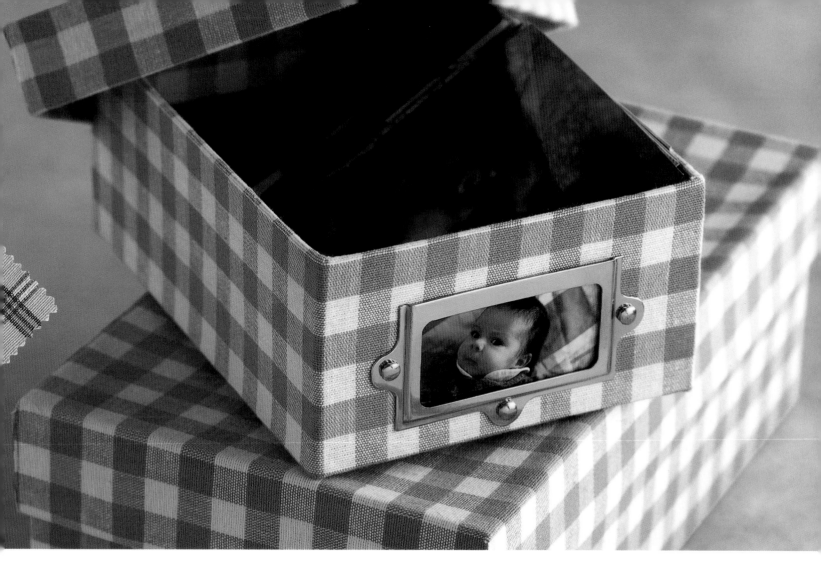

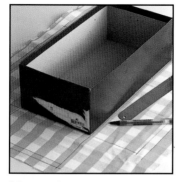

2 Remove the box and, using a ruler, go over the lines and add rectangles all round to correspond to the shape and size of the sides and end of the box. To these, add 1cm (1/2in) flaps, to overlap at corners and tuck inside the box, for a neat finish.

3 Cut out the fabric or paper. Brush the base and all four sides of the box with PVA glue and position it in the centre of the cut-out material. Bring up the two side pieces and smooth out any air bubbles, then bring up the two end pieces.

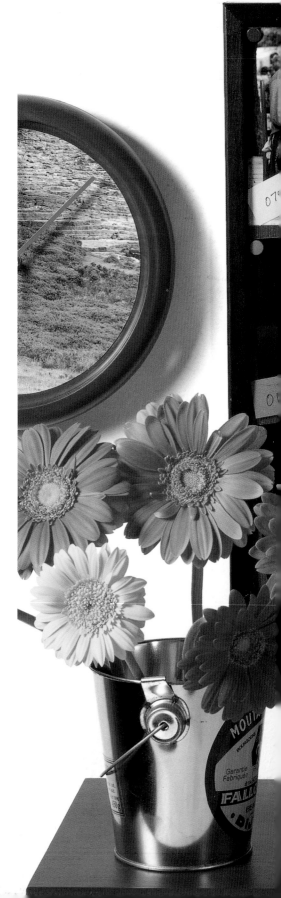

Family & Friends

Instead of hiding them away in a book, display the telephone numbers of special people on a pinboard above the telephone – and you'll have far fewer excuses not to ring them!

Simply trim photographs so they take up a bit less room, pin them to the board and stick on the appropriate phone number, written or typed on a scrap of paper. You could add addresses too, or birth dates so you'll remember to send a card.

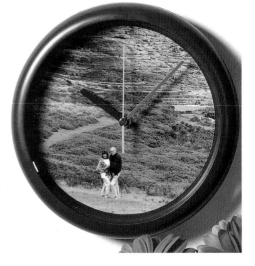

ALONGSIDE YOUR TELEPHONE PINBOARD, KEEP A NOTE BLOCK FOR MESSAGES AND A CLOCK, ALSO DECORATED WITH PHOTOGRAPHS.

TO MAKE A PHOTO CLOCK, SIMPLY LOOK FOR AN INEXPENSIVE CLOCK WITH A BATTERY MOVEMENT. THIS ONE HAS A RED PLASTIC FRAME AND WAS EASILY DISMANTLED BY REMOVING ONE SCREW AND PRISING OFF THE CIRCLE OF CLEAR PLASTIC PROTECTING THE CLOCK FACE. THIS CIRCLE WAS USED AS A TEMPLATE TO CUT THE PHOTOGRAPH TO SIZE, THEN THE PHOTO WAS GLUED IN PLACE AND THE CLOCK REASSEMBLED.

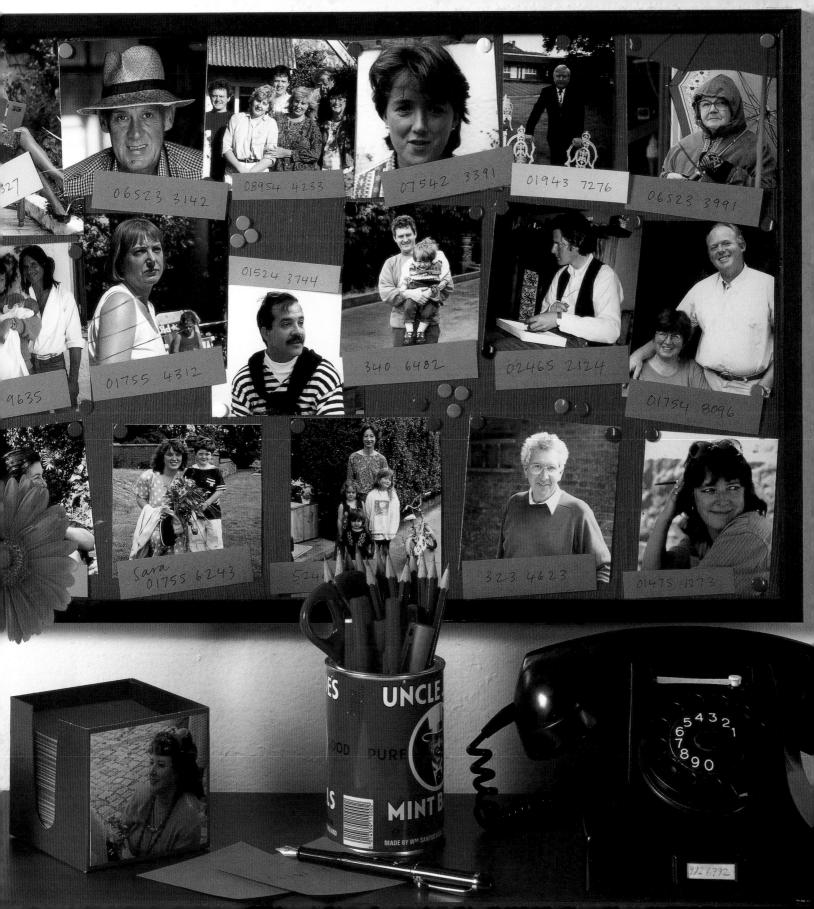

Dressing Table Sets

Your dressing table is a very personal space and so it is probably one of the best places to display special mementoes such as family photographs. Look for powder pots and pill boxes, usually sold in specialist craft shops for displaying needlework. Lockets, old or new, allow you to carry a tiny portrait quite discreetly, wherever you go.

THE SILVER SET, RIGHT, COMPRISES A TRAY, PILL BOX, POWDER BOX, OVAL FRAME, BROOCH AND TWO LOCKETS, ALL OF WHICH LOOK LOVELY DECORATED WITH A PRECIOUS COLLECTION OF BLACK AND WHITE PORTRAITS.

THE GILT CASKET AND BROOCH, BELOW, DISPLAY PICTURES OF TEDDY BEARS BUT WOULD LOOK EQUALLY CHARMING WITH HOLIDAY SCENES, FLOWERS OR COLOUR PORTRAITS.

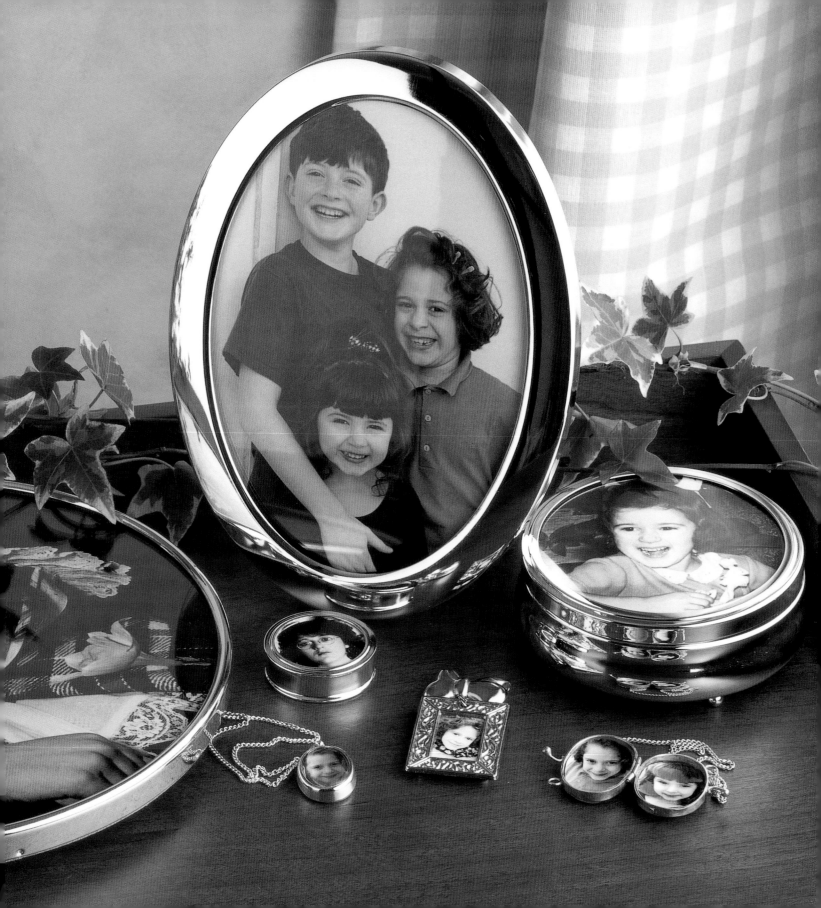

Tissue Box, Trinket Box

Many furnishing companies sell blank pieces ready to be decorated. Buy them from stores or by mail order; they are inexpensive and can be customized in any way you like.

This lidded box and tissue box cover have simply been painted, using several layers of acrylic paints, and distressed by sandpaper (for more details of this technique, see the key racks on page 24), then decorated with photographic prints.

Make a set for your own home, painted in colours to match existing furnishings, or give them as gifts.

A plain lampshade can be decorated with colour photocopies, cut to size and stuck in place using PVA glue, fabric glue or a spray adhesive.

Materials & Equipment

blank boxes
gesso or flat latex paint
acrylic craft paint
spray adhesive or
all-purpose glue

Step-by-Step

1 Blank boxes are usually made from medium-density overlay and need little preparation, though it is a good idea to paint on a coat of primer, either gesso or flat latex paint, to give a good surface for painting.

2 Paint your box with two or three coats of craft paint; leave to dry thoroughly, between coats, then sand to reveal patches of different colours.

3 Cut pictures to size and stick in place, using spray adhesive or an all-purpose glue.

COLOUR PHOTOCOPIES DECORATE A PLAIN
FABRIC LAMPSHADE, THE PERFECT PARTNER
TO A PAIR OF PAINTED BOXES.

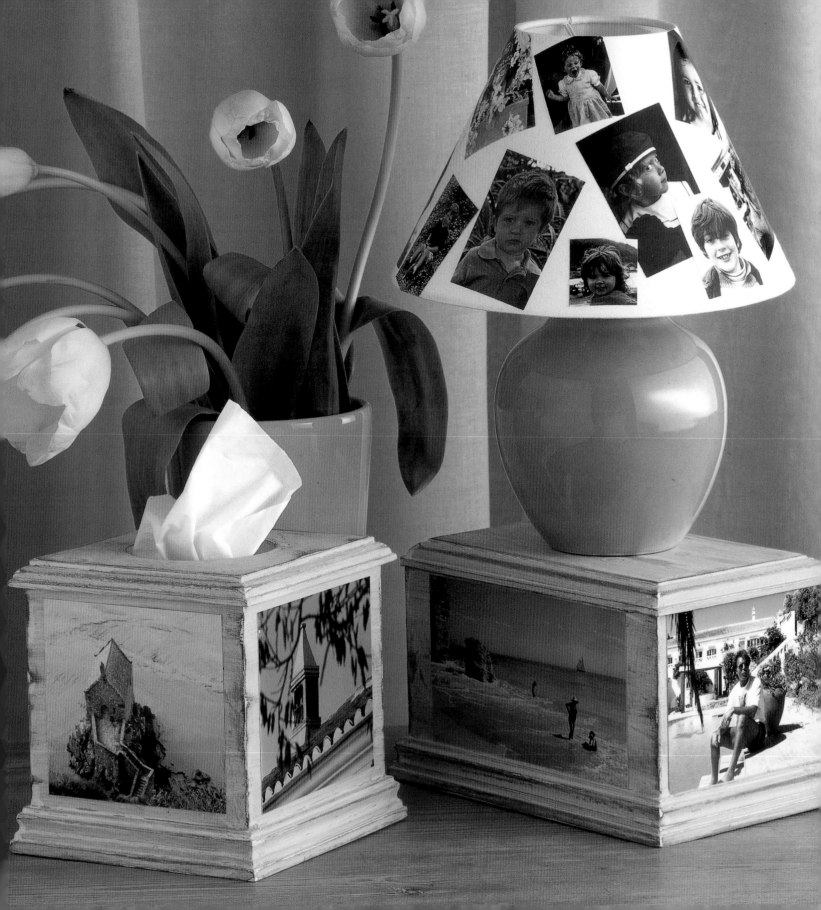

Height Chart

Many of us record our children's growth by marking notches on a door frame but here is an original idea for a more visual record.

Attach a wooden ruler or a tape measure to a wall or door, using adhesive, or by drilling and screwing in place.

As you mark off your child's height, add a recent photograph as a permanent reminder of his or her progress. You could cut the prints to a point, or mount them in tiny frames and cut arrows from cardboard to indicate measurements.

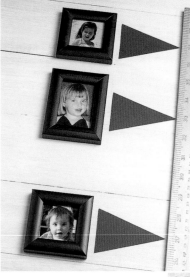

MOUNT PHOTOGRAPHS IN SMALL FRAMES AND USE ARROWS CUT FROM CARDBOARD TO MARK YOUR CHILD'S HEIGHT.

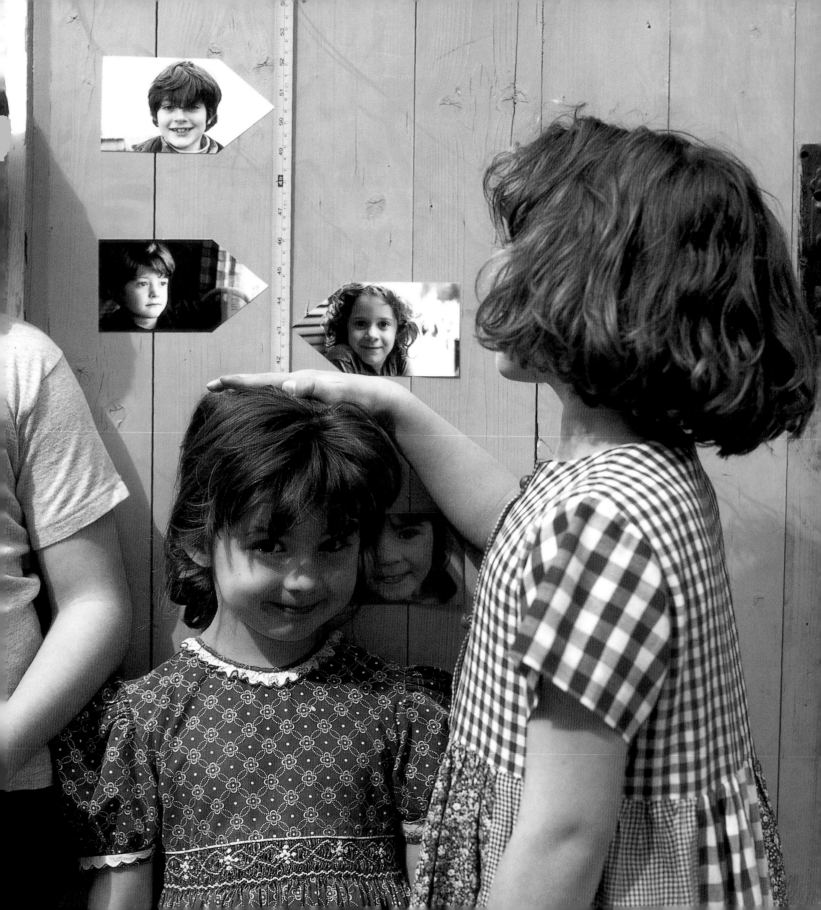

Key Racks

Paint a small plaque, add some hooks to hang your keys and decorate with pictures of your house and car – or whatever the keys are for.

The distressed effect of these two plaques has been achieved with layers of paint and a water-based crackle glaze, available from craft shops and specialist paint suppliers.

The red plaque, made from medium-density overlay, was primed and painted dark green. After a layer of crackle glaze, red acrylic was applied quickly. The green plaque, after priming, was painted yellow, then dark green, and given a coat of crackle glaze before a final coat of light green. When dry, the pieces were lightly sanded.

Photographs were trimmed to size and stuck on with a strong spray adhesive. A final protective coat of clear gloss varnish was then brushed on.

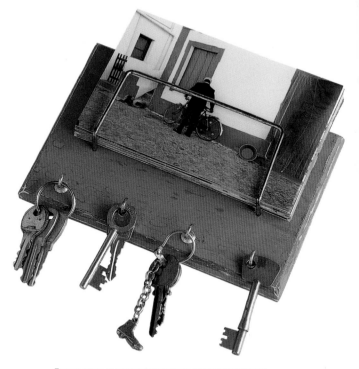

EITHER STICK ON PHOTOGRAPHS TO INDICATE WHAT THE KEYS ARE FOR, RIGHT, OR ADD A WIRE HOLDER TO STORE LOOSE PRINTS, AS IN THE EXAMPLE ABOVE.

Materials & Equipment

blank plaque
gesso primer
craft paints or acrylics
water-based crackle glaze
spray adhesive
fine sandpaper
polyurethane gloss varnish
brass hooks

I Paint the blank plaque with two coats of primer, allowing it to dry thoroughly between coats. When dry, paint with base colour, in this case a pale blue.

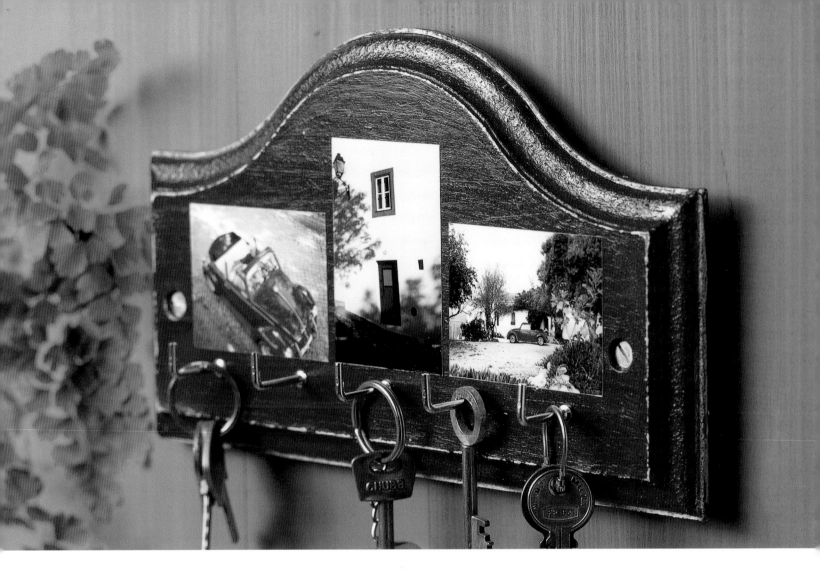

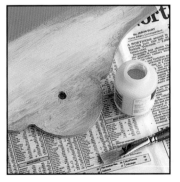

2 When the base colour is dry, brush with a layer of crackle glaze and leave to dry for about 2 hours. Now add a top coat of colour, such as this yellow, with all the brushstrokes going in the same direction.

3 When dry, rub with sandpaper partially exposing the layers of paint beneath, especially on the edges, to simulate wear and tear. Trim photos to size and stick in place using a strong spray adhesive. Protect with a layer of varnish.

Personalized Pegs

A great way to organize household clutter is to give each family member a capacious bag and his or her own hook on which to hang it. Put a peg rack in the kitchen, the bathroom or the hall – or perhaps you should put one in every room in the house?

So that no one is in doubt as to who owns which peg, label each with a portrait.

Peg racks made from unfinished wood or medium-density overlay can be bought by mail order or from shops specializing in furnishing blanks – or you can make your own if you are handy with wood and nails.

Prime raw wood with gesso then paint with one or two coats of flat latex or acrylic paint. Add a protective coat of varnish to prevent the paintwork becoming damaged.

A COLOURFUL PEG RACK SERVES A DUAL PURPOSE, AS HANDY STORAGE AND QUIRKY DECORATION.

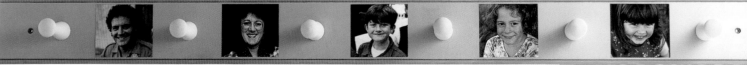

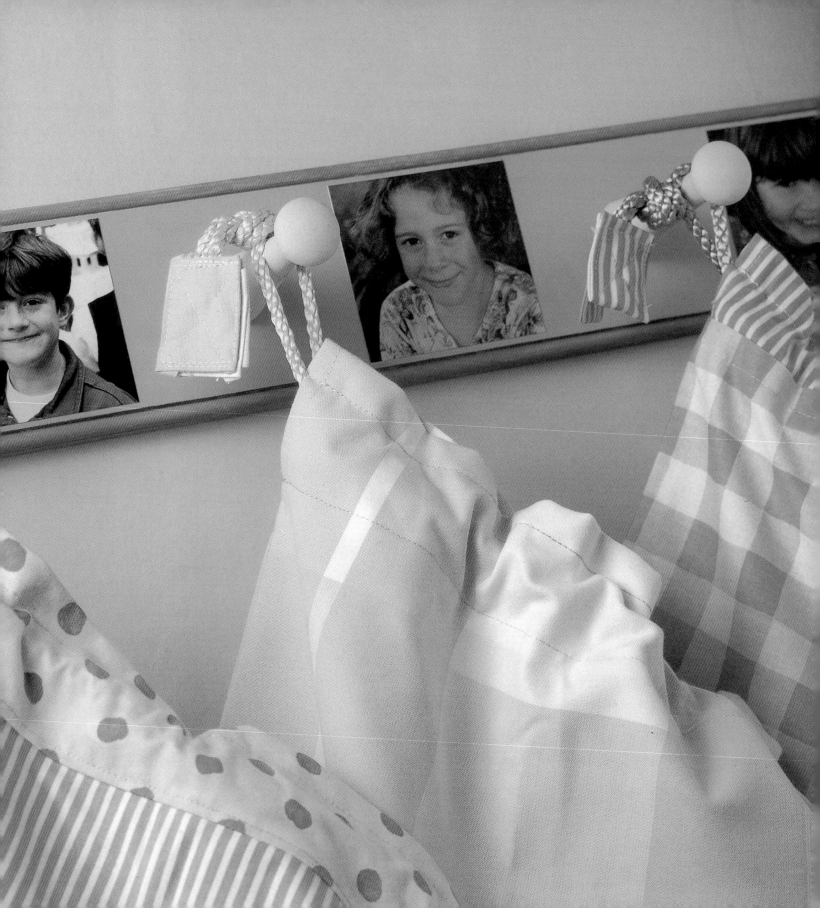

Shoe Bags

Following on from the idea of hanging storage on the previous page, here are some useful cloth bags that have been personalized with photographs. The ones pictured are intended for carrying shoes but you could adapt them to another purpose.

A special solution is used to transfer the photographic image to fabric and the technique is straightforward – but be sure to read the manufacturer's instructions carefully.

Materials & Equipment

Dylon Image Maker
white fabric
sheet of plastic
paintbrush
kitchen paper
roller
scissors

Step-by-Step

1 Make a photocopy – colour or black-and-white – of the photograph you wish to transfer. Trim the image to the shape and size you want, then cover it with a coat of the image transfer solution, brushing it on thickly and evenly.

2 Place the fabric on a piece of plastic, then put the coated picture face down on the fabric. Cover with a piece of kitchen paper and press down, using a roller.

3 Remove the kitchen paper and leave to dry for at least four hours, or overnight.

4 Remove the paper from the transfer by rubbing with a damp sponge, then leave to dry. Trim the fabric, leaving a 1cm (1/2in) border all round the image, fold under raw edges, then stitch in place.

THE IMAGES USED FOR THESE BAGS EACH MEASURE 10CM (4IN) SQUARE. TO MAKE AN UNLINED BAG, CUT A PIECE OF PLAIN FURNISHING FABRIC 60CM X 30CM (24IN X 12IN). PIN THE FABRIC PICTURE IN POSITION AND MACHINE STITCH IN PLACE WITH A CLOSE ZIGZAG, THEN FOLD IN HALF WITH RIGHT SIDES FACING AND STITCH THE TWO SIDE SEAMS OF THE BAG. CUT A PIECE OF BINDING FROM CONTRASTING FABRIC, 6CM (21/2IN) WIDE, AND USE TO BIND THE TOP EDGES AND MAKE HANDLES.

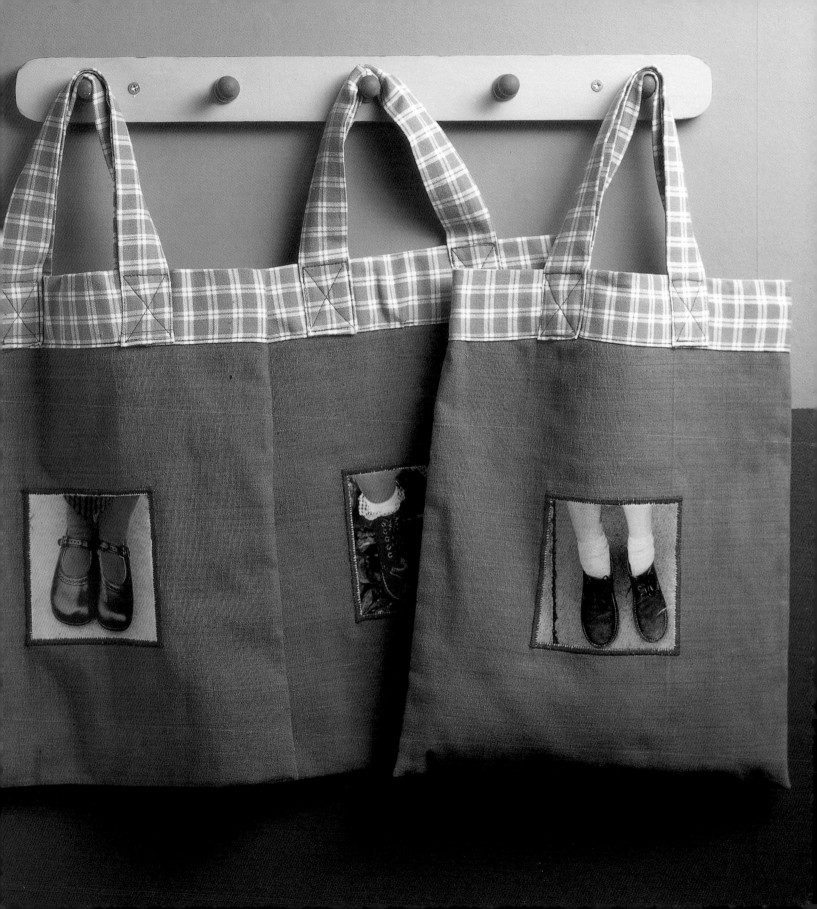

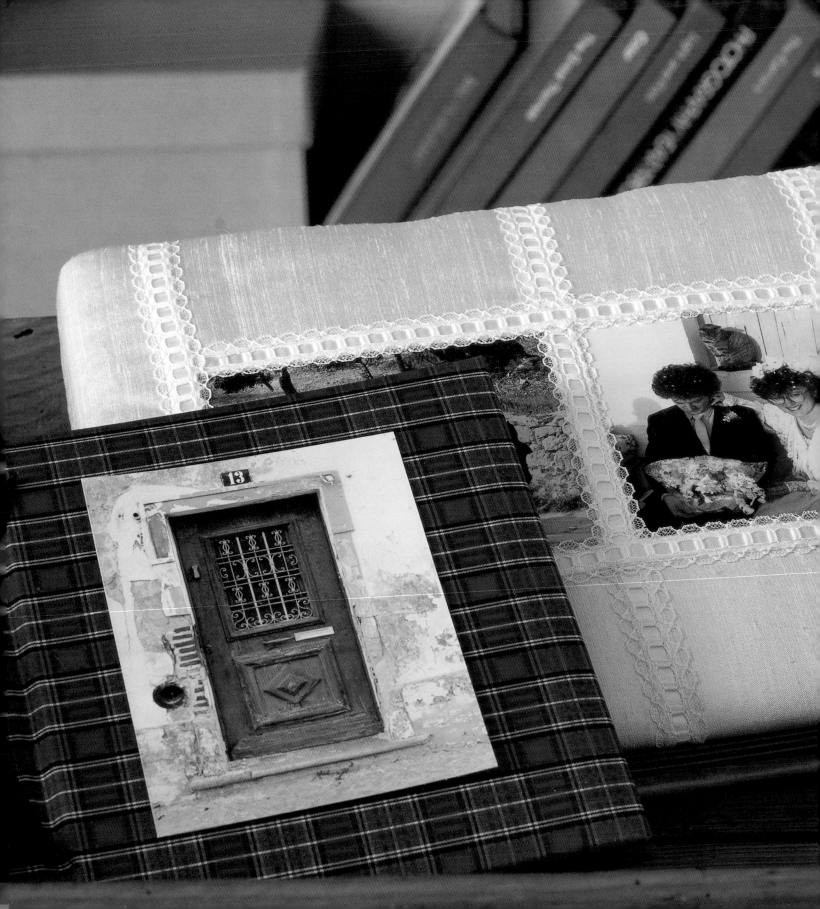

Books and Albums

Take a little time to put together a collection of photographs to treasure forever – an album you'll be proud to show your friends.

Baby Book

The birth of a baby is excuse enough to buy a camera and those first pictures are very precious. Preserve them in a special album, deceptively easy to make from paper and cardboard – leftovers of nursery wallpaper make an ideal cover.

This small album is just the right size to fit a standard print on every page, but once you have mastered the technique you can produce custom-made albums of any shape and size.

The Step-by-Step instructions tell you how to make the cover. Make the pages from thick paper, cutting them the same size as the lining paper. Punch holes to correspond with the holes in the spine, thread a piece of ribbon or cord through and tie in a bow at the front, to hold them in place. Remember to reserve at least one special picture to decorate the cover.

SHADES OF BLUE MAKE A PRETTY COVER FOR A VERY SPECIAL BABY ALBUM. FOR A FINISHING TOUCH, ADD RIBBONS AND, OF COURSE, A PHOTOGRAPH.

Materials & Equipment

thick cardboard
wallpaper
paper-backed fabric or
bookbinder's linen
craft knife
steel ruler
all-purpose glue
punch
ribbon or cord

1 Cut covers and spine from thick cardboard. In this case, the covers measure 20cm x 13cm (8in x 5in); the spine measures 13cm x 7cm (5in x 3in). Score lines along the length of the spine to create a central section of 2cm (3/4in), with 2.5cm (1in) on either side.

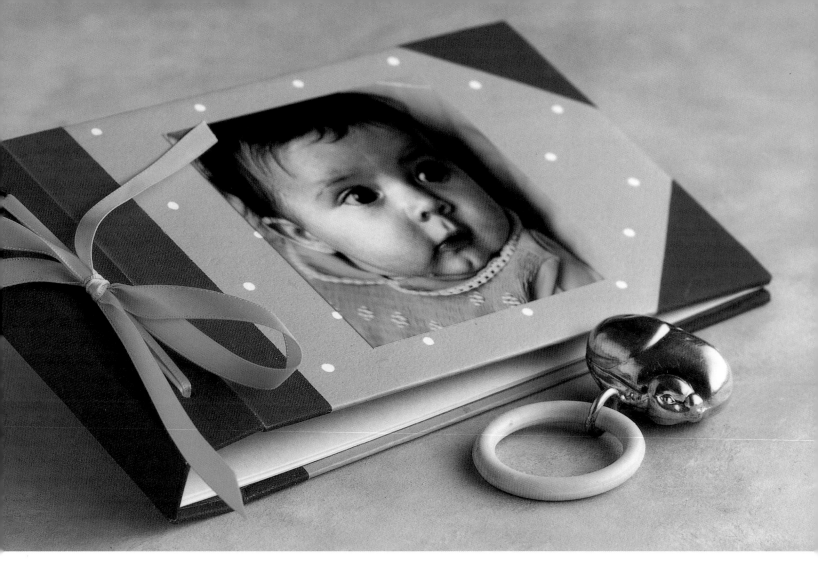

2 Cut wallpaper or other covering to fit front and back covers with approximately 3 cm (1 1/4 in) all round for turnings and glue in place. Cut corner pieces from non-fray fabric and glue in place, to reinforce and protect corners.

3 Cut a piece of non-fray fabric measuring 17 cm x 12 cm (6 3/4 in x 4 3/4 in), to cover spine. Apply glue to prepared cardboard and stick centrally on to fabric. Mark positions of holes and cut out, using a punch.

4 Apply glue to remaining fabric overlap and stick spine to covers, as shown. Fold excess fabric over. Cut two pieces of lining paper, each measuring 22 cm x 12.5 cm (8 3/4 in x 5 in), and stick in place.

Childhood Record Book

Children grow so quickly it is a good idea to keep a special book, including drawings, letters and other memorabilia, as well as photographs, to record a child's progress.

Make your own album, buy one, or simply use a loose-leaf file, covered in your own choice of material, to which you can add extra pages as your child develops.

You can involve the children themselves in the making of the book, letting them add captions to each picture.

A book like this is great fun to make and will be treasured forever.

HERE THE BLANK PAGES OF HARDBACKED NOTEBOOKS ARE FILLED WITH PICTURES, SCRAPS AND NOTES.

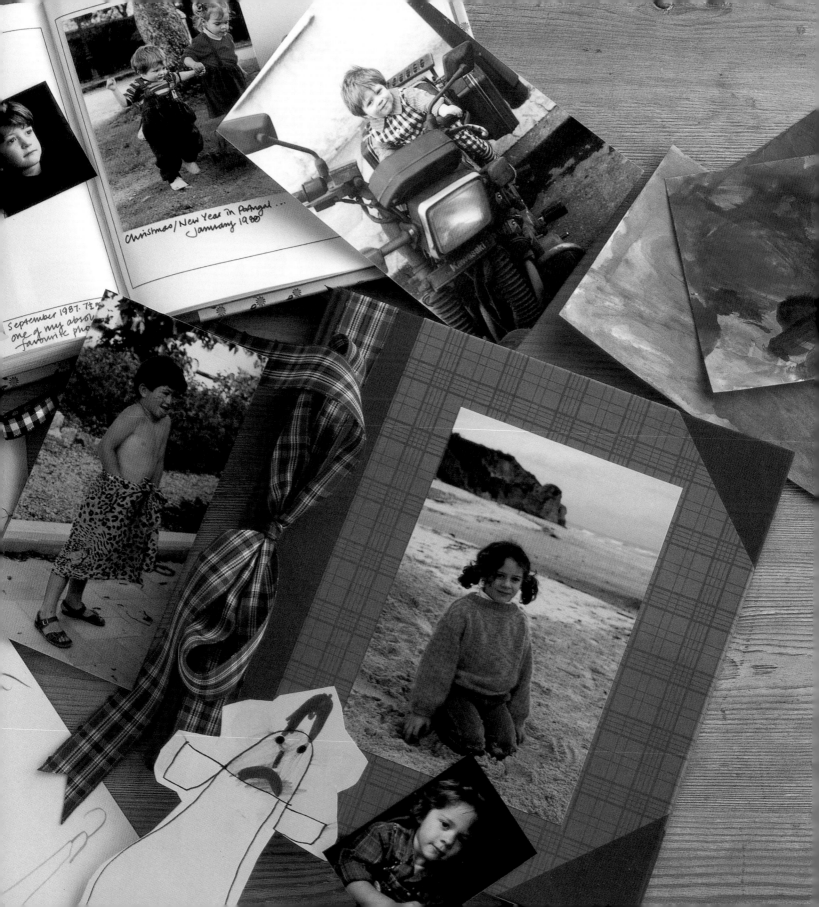

Christmas / New Year in Portugal ...
January 1980

september 1987. 7½
one of my abso...
favourite pho...

Family Album

Old photographs sometimes require special treatment. For example, you may not wish to use adhesives to hold them in place, in which case an album with plastic sleeves into which the pictures can be slipped is one option, while old-fashioned photo corners are another.

If you cannot find the right style of photograph album to buy, try adapting other kinds of stationery to the purpose – ring binders, notebooks, sketch books and so on. And if the pages of the album are just right but the cover does not evoke the right mood, recover it in your choice of fabric or paper. Or simply make your own album from scratch, following the instructions for the baby book on page 32.

EVERY PICTURE TELLS A STORY, OR SO THE SAYING GOES. MAKE YOUR FAMILY ALBUM MORE INTERESTING BY ADDING NAMES, DATES AND OTHER INFORMATION ALONGSIDE ANTIQUE PHOTOGRAPHS, USING PEN AND INK RATHER THAN A MODERN BALLPOINT, TO REFLECT THE STYLE OF A BYGONE AGE.

SEARCH IN STATIONERY STORES UNTIL YOU FIND THE RIGHT PRODUCT. THIS RING BINDER HAS PLASTIC POCKETS JUST THE RIGHT SIZE FOR A COLLECTION OF OLD FAMILY PHOTOS.

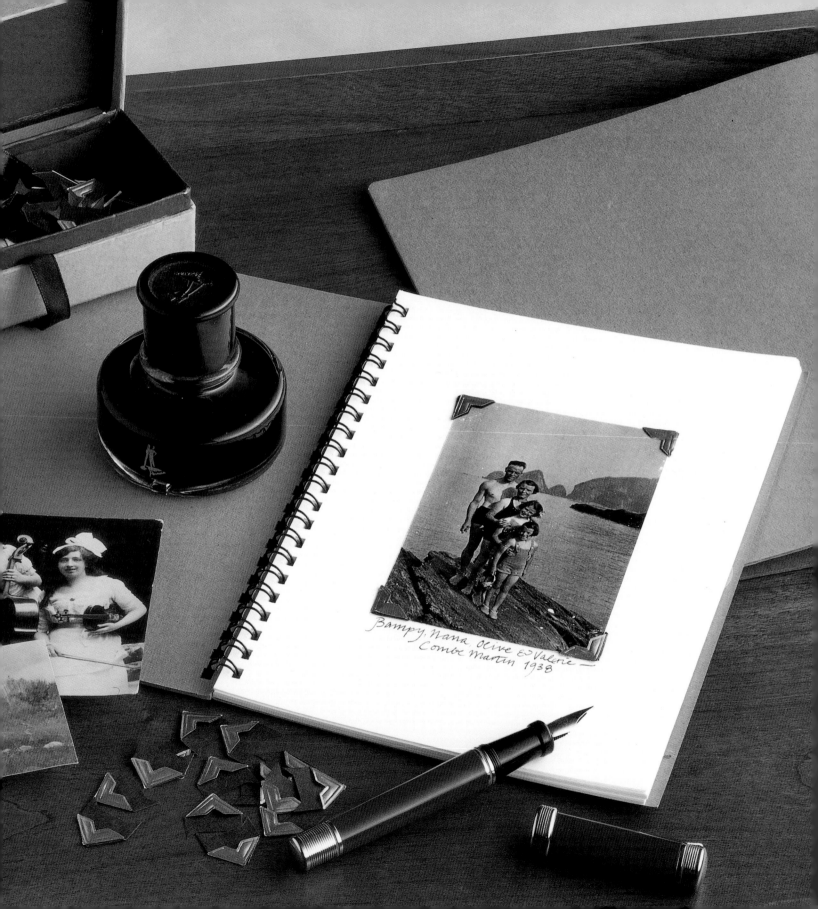

Bampy, Nana Olive & Valerie —
Combe Martin 1938

Wedding Album

Wedding photography is big business, and the bride and groom who hire a professional to take pictures of their special day will be offered a choice of photo packages, including an album.

On the day, however, friends and family usually like to make their own photographic record and most happy couples end up with a batch of unofficial photographs, as well as the formal ones.

You will find specially-designed wedding photo albums in the shops but might prefer to make your own. Follow the instructions for the baby album on page 32 or buy a plain album and cover it with a piece of your wedding dress fabric, and a touch of lace.

To make an album cover like the one in the picture, the method is similar to that used for the fabric frames on page 50.

Materials & Equipment

album
polyester wadding
silk fabric
paper (for lining)
lace, ribbon
spray adhesive
punch
craft knife
steel ruler
scissors

Step-by-Step

1 Open out the album and cut a piece of wadding exactly the same size. Then cut out out a piece of fabric at least 2.5cm (1in) larger all round.

2 Stick or stitch photos to the fabric, adding borders of lace and ribbons.

3 Using a strong spray craft adhesive, spray the outside covers of the album and cover with the piece of wadding. Spray the wadding and place the album centrally on the wrong side of the fabric. Clip the corners of the fabric and fold the raw edges to the inside of the covers.

4 Punch a hole in each edge of the cover and thread a piece of ribbon through each, sticking in place. Cut two pieces of paper slightly smaller than the front and back of the album and glue in place, to cover all the raw edges of fabric and ribbon.

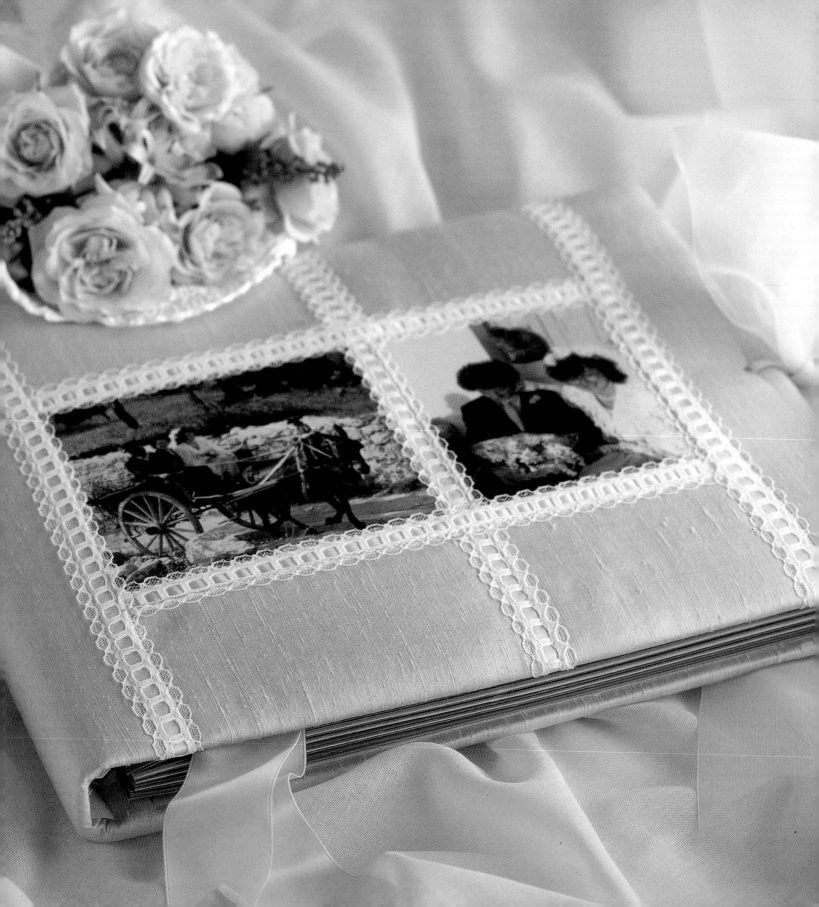

Holiday Scrapbook

A suntan quickly fades, but photographs are a long-lasting record of rest and relaxation, foreign travel, sightseeing – in other words, happy holiday memories.

Next time you go on holiday, plan to make your photographs as interesting and varied as possible. You'll find some useful tips on page 123.

In the meantime, sort out snaps from previous trips and stick them in an album – along with bus tickets, receipts, labels and other items you may have kept – and add some witty captions, too.

When friends call, you'll be proud to show them an organized and entertaining album instead of an untidy handful of unedited prints.

SAVE A FAVOURITE SNAP TO DECORATE THE COVER OF YOUR HOLIDAY SOUVENIR ALBUM.

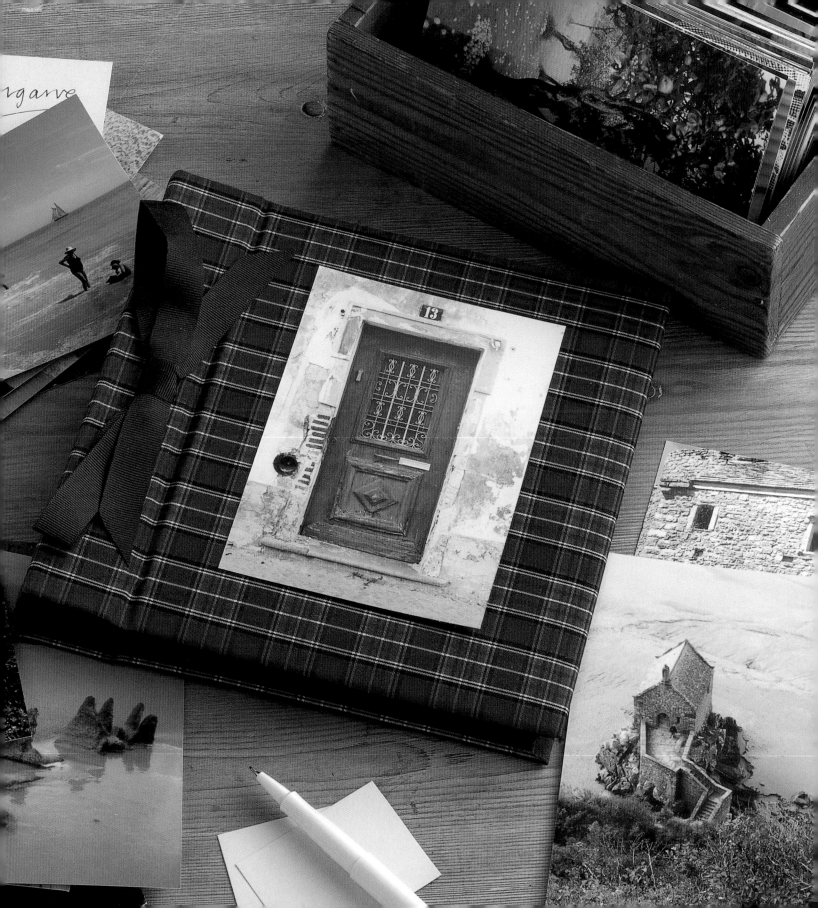

Portfolio

If you don't want to stick pictures on a page, a portfolio may be the answer. Here is a way of keeping photographs and related documents, drawings and other precious papers together without having to stick them down.

Customize a shop-bought portfolio by decorating the cover with photographs, or make your own from cardboard and paper. It's very easy to do, you can make it whatever size you wish, and you can choose fabric to co-ordinate with other stationery, room colour schemes, luggage or whatever.

A handmade portfolio filled with a set of photographs would make a lovely gift for a friend or relative.

DRESS-WEIGHT FABRICS, EITHER PLAIN OR WITH A SMALL REPEAT PATTERN, ARE EASIEST TO USE FOR PORTFOLIOS, BOOK COVERS AND FRAMES.

Materials & Equipment

thick cardboard
thin cardboard
fabric
paper-backed fabric or
bookbinder's linen
carpet tape
ribbon
spray adhesive,
fabric glue or PVA
scissors
craft knife
punch
steel ruler

I Cut two pieces of heavy cardboard, each 20cm x 16cm (8 in x 6 in). Cut two pieces of fabric, 28cm x 20cm (11 in x 8 in). Cover one side of the cardboard pieces with glue and place in the centre of the fabric. Clip corners and fold over excess fabric, gluing in place.

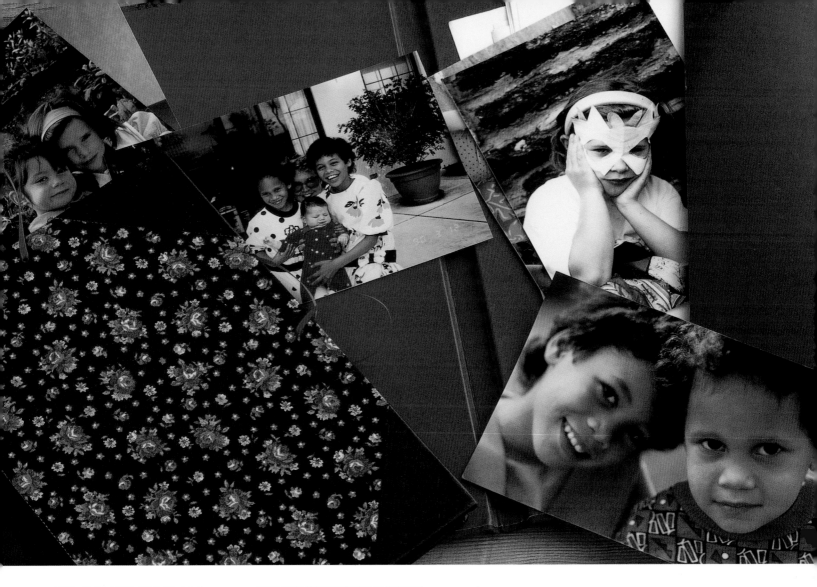

2 From 5cm (2in) wide self-adhesive carpet tape, cut four pieces each 9cm (3 1/2in) in length, for corner protectors, and one piece 28cm (11in) long, for the spine. Stick on a strip of thin cardboard, 20cm x 2.5cm (8in x 1in), to reinforce the spine.

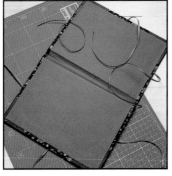

3 Punch holes in back and front covers at mid-point on all three open edges. Cut six pieces of narrow ribbon, cord or tape, each about 30cm (12in) in length and thread one through each hole, sticking in place on the inside.

LINE YOUR PORTFOLIO WITH A PIECE OF PAPER-BACKED FABRIC OR BOOKBINDER'S LINEN, CUT TO SIZE, AND STUCK IN PLACE.

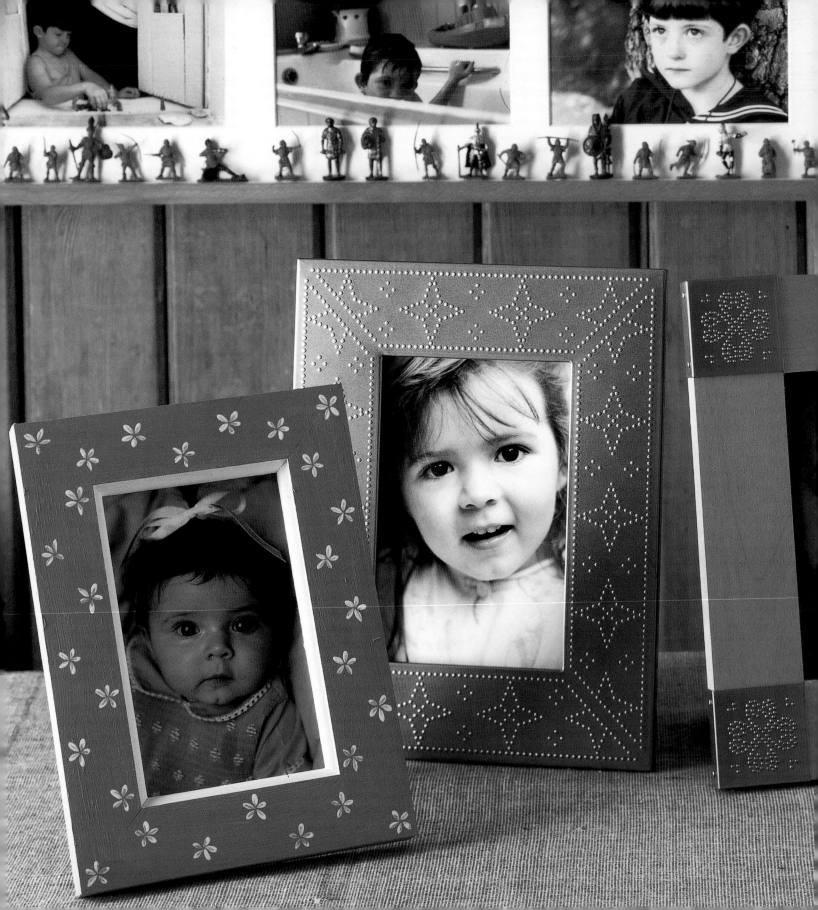

Framing and Collections

When you put a picture in a frame you draw attention to it and give it importance. Don't hide special pictures away – put them in pride of place.

Decorative Mounts

Give any picture extra impact with a decorated border. Create your own design to complement the picture or to co-ordinate with a room scheme.

You can cut your own mounts, have them cut to your specifications by a framer, or buy them ready-made. Most craft shops and picture framers sell a wide range of ready-cut mounts and you can use your artistic skills to customize them. Cardboard mounts can be decorated with rubber stamps or stickers, or by painting on designs with watercolours. The possibilities are limited only by your talent and your imagination.

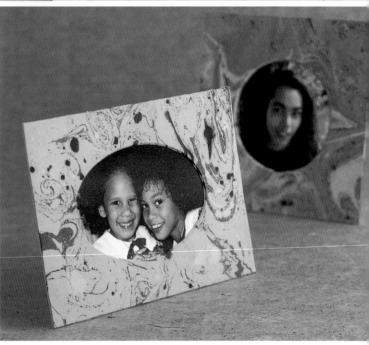

TOP: PHOTOCOPY OLD LETTERS OR MANUSCRIPTS ON TO CREAM OR IVORY PAPER, STICK TO MOUNTING CARDBOARD AND CUT TO SIZE, TO ADD A TOUCH OF SENTIMENT TO AN OLD PRINT.

BOTTOM: FILL A TRAY WITH WATER, FLOAT DROPS OF OIL PAINT ON THE SURFACE, AND DIP IN READY-CUT MOUNTS FOR A MARVELLOUS MARBLED EFFECT.

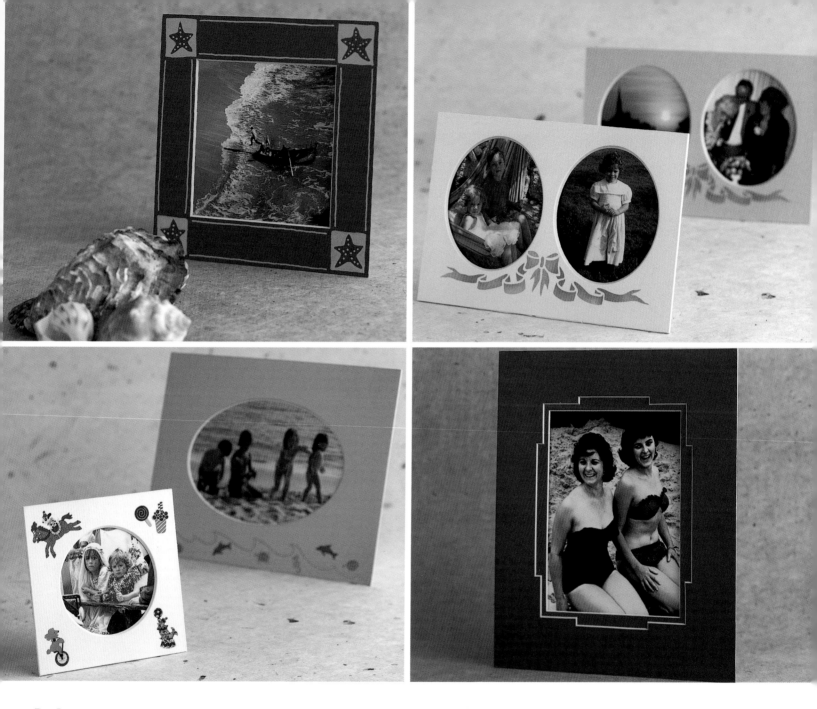

TOP: DECORATE A PLAIN CARDBOARD MOUNT WITH POSTER PAINT, USING A SIMPLE MOTIF TO COMPLEMENT THE SUBJECT OF THE PHOTOGRAPH.

BOTTOM: ADD A BORDER OF DECORATIVE STICKERS TO MATCH THE MOOD OF THE PICTURE IN THE FRAME — THERE ARE SO MANY DESIGNS TO CHOOSE FROM.

TOP: STENCILLING ADDS AN ELEGANT FINISH AND IS EASY TO DO. CUT YOUR OWN STENCILS OR BUY THEM READY-MADE, AND USE PAINTS, FELT-TIP PENS OR COLOURED PENCILS.

BOTTOM: A DOUBLE MOUNT LOOKS REALLY PROFESSIONAL. IF YOUR HAND IS NOT STEADY ENOUGH, ASK A PICTURE FRAMER TO CUT ONE TO YOUR REQUIREMENTS.

Painted Frames

Like the mounts on the previous pages, these frames have been decorated to match the photographs. Even if your artistic skills are limited, the effects are easy to achieve.

THE RED SPOTTED FRAME STARTED LIFE AS AN INEXPENSIVE PLAIN WOODEN ONE. IT WAS LIGHTLY SANDED AND GIVEN TWO COATS OF RED ACRYLIC PAINT. TO ADD SPOTS, DIP THE WRONG END OF A PENCIL OR PAINTBRUSH INTO WHITE PAINT.

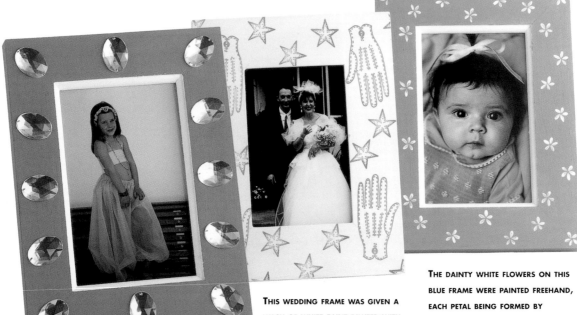

TO COMPLEMENT THE EXOTIC PICTURE IN THE PINK FRAME, FAKE JEWELS, STUCK IN PLACE WITH A STRONG ALL-PURPOSE GLUE, ADD A TOUCH OF SPARKLE.

THIS WEDDING FRAME WAS GIVEN A WASH OF WHITE PAINT DILUTED WITH AN EQUAL AMOUNT OF WATER. THE DESIGNS WERE PRINTED ON, USING RUBBER STAMPS AND A GREEN INK PAD.

THE DAINTY WHITE FLOWERS ON THIS BLUE FRAME WERE PAINTED FREEHAND, EACH PETAL BEING FORMED BY LOADING A FINE WATERCOLOUR BRUSH WITH PAINT AND LAYING THE PAINT ON THE FRAME USING THE SIDE OF THE BRISTLES.

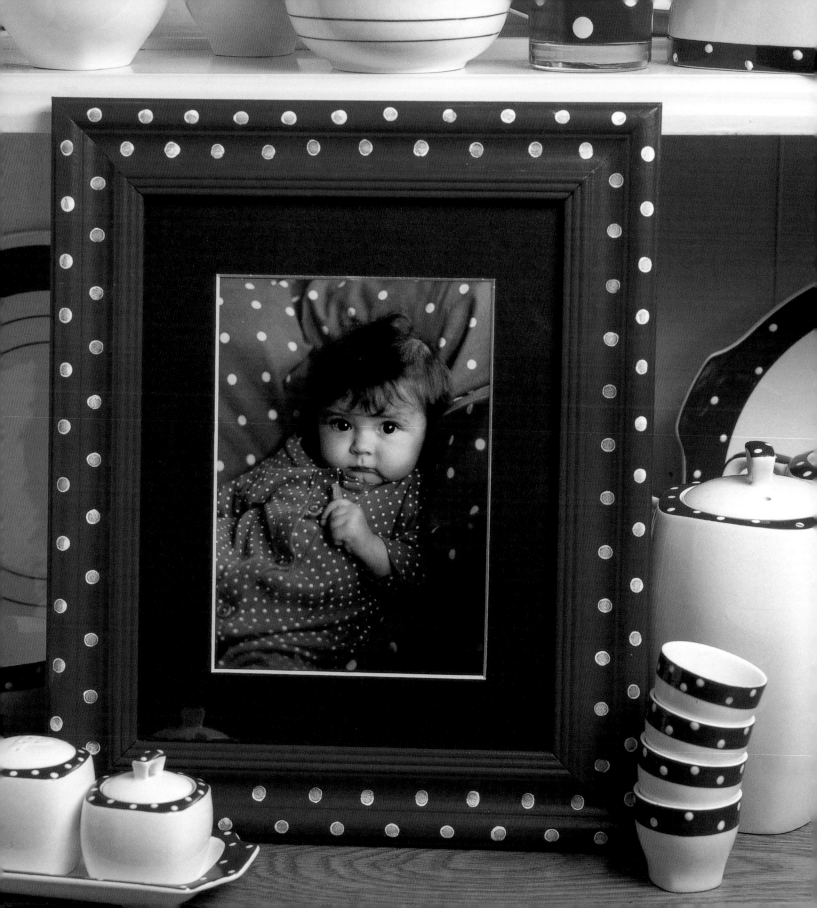

Fabric Frames

Fabric frames are easy to make, with a base cut from cardboard, wadding to give a padded effect, and almost any kind of fabric.

This is a great idea for framing wedding pictures, using a piece of bridal fabric, a baby picture, flower picture, pet portrait – or anything you wish. You could make matching storage boxes, following the instructions on page 14, and a covered album, as on page 38.

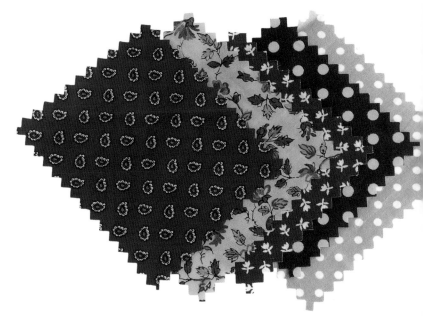

HOME-MADE FRAMES CAN BE ANY SIZE AND SHAPE YOU LIKE – AND COVERED IN ANY MATERIAL YOU WISH. MAKE AN ALBUM (PAGE **32**) AND A PORTFOLIO (PAGE **42**) TO MATCH.

Materials & Equipment

thick cardboard
polyester wadding
fabric
spray adhesive or fabric glue
craft knife
steel ruler
scissors

I Cut two pieces of cardboard, 20cm x 16cm (8in x 6in). Cut a window in one of the pieces, using the template on page 126 as a guide. Cut a piece of wadding the same size; cut two pieces of fabric, 2cm (3/4in) larger all round.

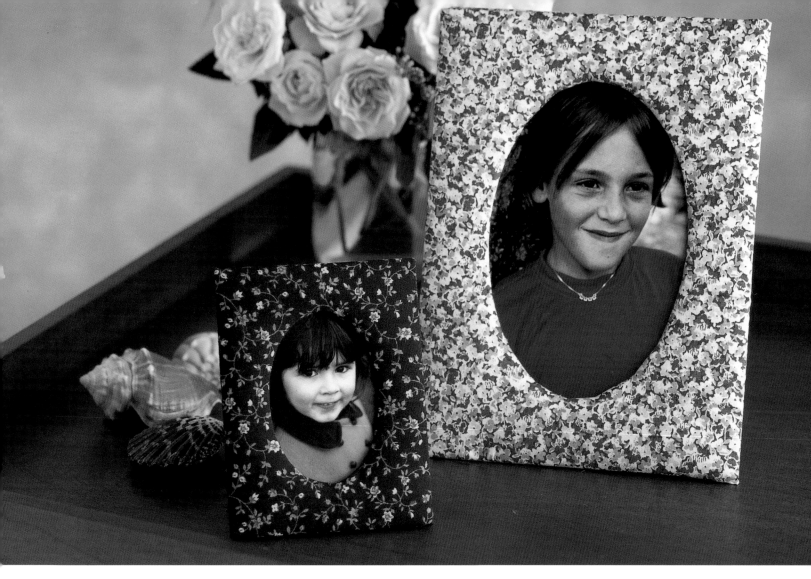

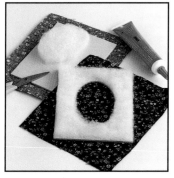

2 Spray one side of the window mount with a strong craft adhesive, or spread with fabric glue. Place it, glue side down, on the wadding and leave to dry, then cut away the wadding from the aperture.

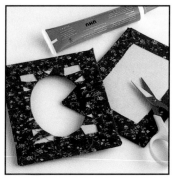

3 Place the frame, wadding side down, on the wrong side of one of the fabric pieces. Fold the fabric edges over to the back of the cardboard and glue them in place. Cover the other piece of cardboard with fabric.

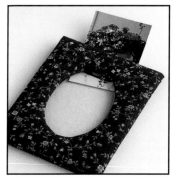

4 Glue or stitch the two pieces of fabric-covered cardboard together around three edges, leaving one side open so that a photograph can be slipped inside.

Mosaic Mirror Frame

In the spirit of recycling, here is a way of making use of even the tiniest leftovers from your photographic prints.

When trimming prints for use in any of the other projects in this book, save the bits you cut off. Mount them on thick cardboard, then cut the cardboard into small pieces, using a craft knife and a steel ruler. The pieces should be more or less the same size but it doesn't matter if they differ slightly in shape as it adds to the overall effect.

You now have your own mosaic 'tiles' which can be arranged in a similar way to the tesserae used in traditional mosaics. Here they have been used to create a colourful mirror.

Before starting, sort mosaics into groups of similar patterns and colours. You will need to work quite quickly, while the glue remains wet. If the glue does dry out, add another layer on top.

WHO WOULD HAVE GUESSED THAT THIS SHINY FRAME WAS MADE FROM REJECT PHOTOGRAPHIC PRINTS?

Materials & Equipment

mirror
hardboard
thick cardboard
PVA glue
craft knife
steel ruler

1 Stick a mirror in the centre of a piece of hardboard, using PVA glue, then cover the remaining surface with a thick layer of PVA, spreading it out evenly with a scrap of cardboard.

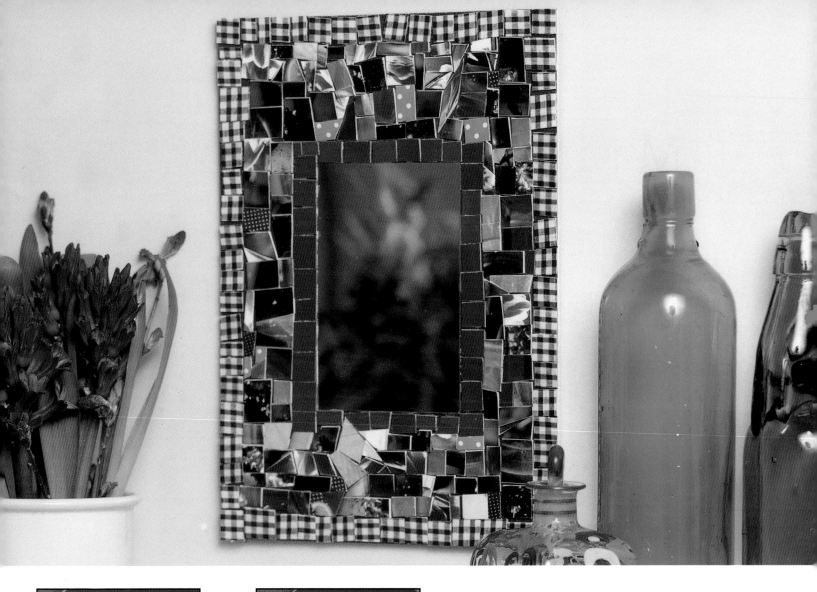

2 Start sticking 'tiles' in place and work quickly, before the glue has time to dry. Position pieces all around the edge of the hardboard, then around the edge of the mirror, pressing them down into the glue.

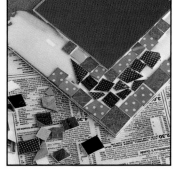

3 Fill in the spaces with the remaining tiles, trimming them where necessary for a good fit. Leave to dry.

Multiples

A series of snapshots, or a number of portraits of one person, often looks good as a multiple display.

Choose a multiple window mount – a piece of thick cardboard with several holes cut in it – or simply stick your pictures on to a firm background before framing.

Ready-cut multiple mounts are widely available, or a picture framer should be able to cut one to your specifications.

A TRIO OF CHARMING PORTRAITS, RIGHT, DISPLAYS THE SIMILARITIES AS WELL AS THE DIFFERENCES BETWEEN BROTHER AND SISTERS, WHILE A SERIES OF PICTURES TAKEN IN RAPID SUCCESSION, FOLLOWS THE PROGRESS OF A TODDLER FALLING OFF A SWING.

THREE PICTURES OF THE SAME CHILD HELP TO SHOW THE DIFFERENT SIDES OF HER CHARACTER.

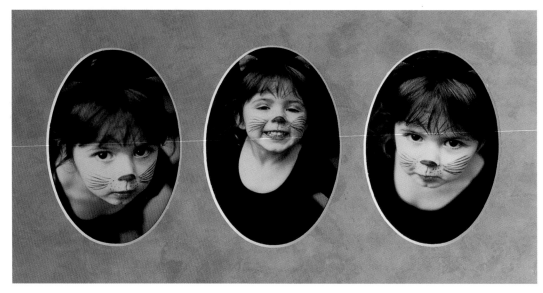

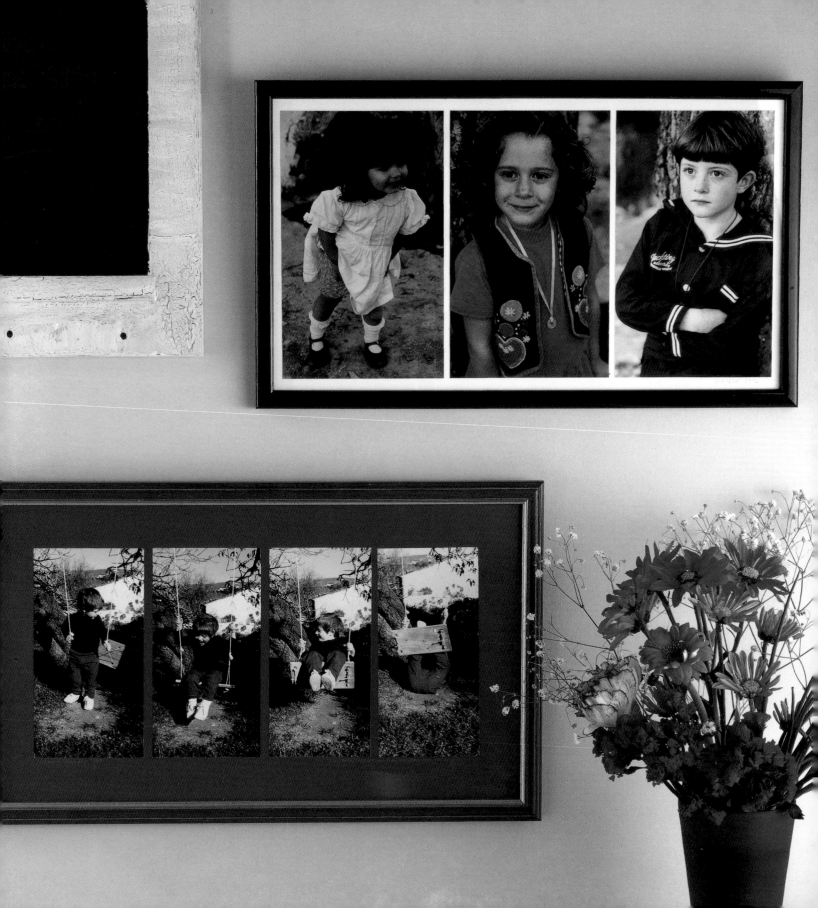

Themes

As on the previous pages, here are some ideas for grouping photographs to make eye-catching displays. In this case, the pictures have been chosen for their related subject matter – swimming pools – or because they have a visual link, such as the deep blue of the sky with bold shapes and architectural features.

You can display a group of linked pictures very effectively in a single frame, as shown on the previous pages, in a number of identical frames, or in a group of different-sized but identically-coloured frames. Experiment with different arrangements before deciding on the final display.

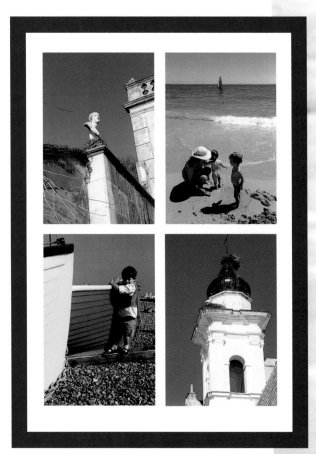

THE PICTURES ABOVE, TAKEN AT DIFFERENT TIMES AND LOCATIONS, ARE LINKED BY THEIR DRAMATIC BLUE SKIES.

CHILDREN'S DRAWINGS CAN BE COMBINED WITH PHOTOS FOR A THEMED MONTAGE, RIGHT. EDITH EVEN PAINTED THE FRAME TO CO-ORDINATE WITH HER COLLECTION, WHILE LILLIE DREW A SWIMMING POOL PICTURE, INSPIRED BY SOME HOLIDAY SNAPS.

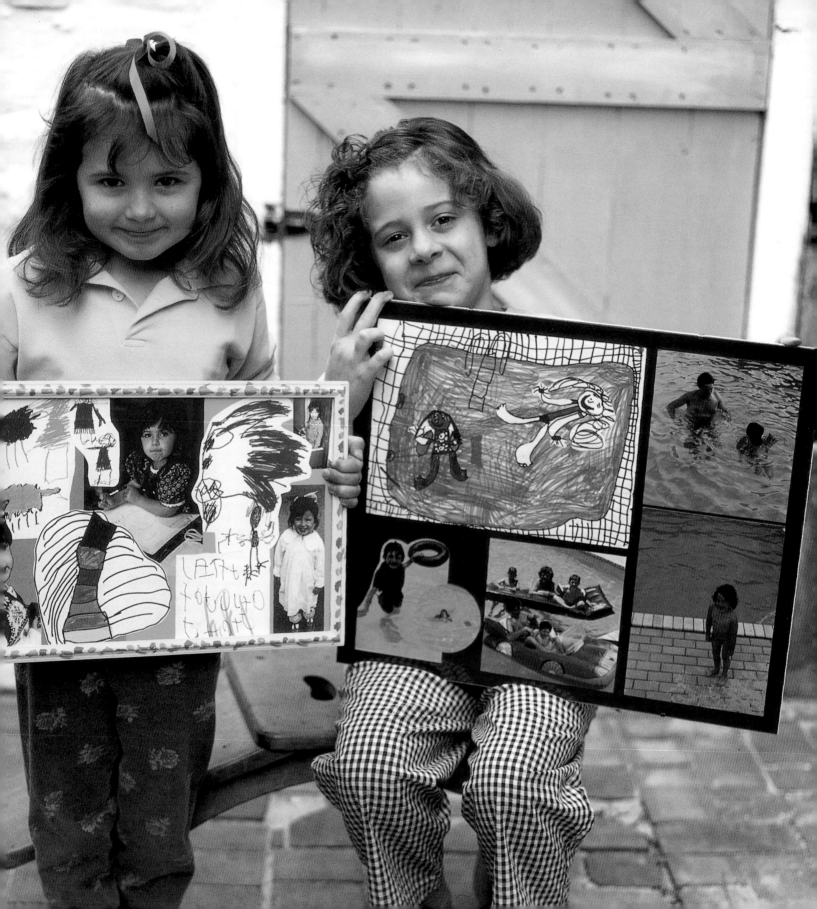

Souvenir Frame

Frame a favourite picture of a child using toys and trinkets.

Children generate a lot of muddle and mess. Just collect together some of this debris – small, discarded or broken toys, incomplete jigsaw puzzles, buttons, diaper pins, barrettes and so on – and preserve them in a highly original frame.

This one, once assembled and glued, has been sprayed gold – but any colour would be just as effective. Blue, white, red green, silver – the choice is yours.

Materials & Equipment

thick cardboard
PVA glue
assorted objects
gold spray paint
craft knife
steel ruler
picture hanger

Step-by-Step

1 Cut a mount from heavy cardboard. This one measures 25cm x 20cm (10in x 8in).

2 Spread a thick layer of PVA glue all over the frame and, while it's still wet, press the objects into position.

3 Leave to dry overnight, then cover with a coat of gold spray paint.

4 When the paint is dry, put your photo in position, back with a plain piece of cardboard and glue a picture hanger to the reverse of the frame.

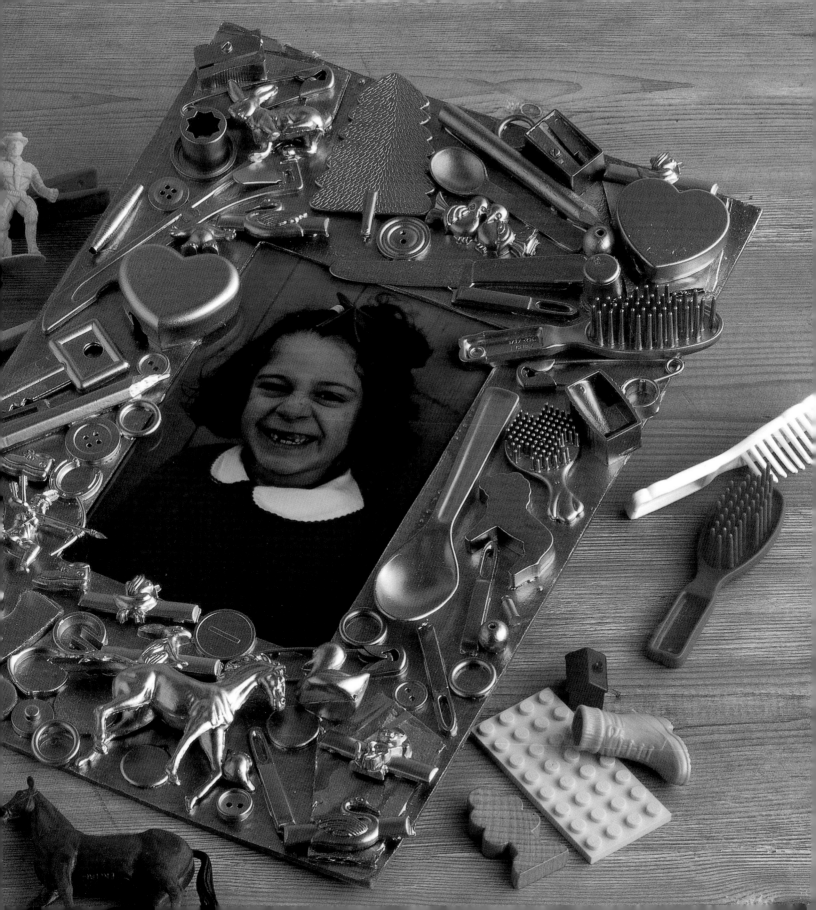

Box Frame

A box frame allows you to display not only photographs but small objects, all behind glass. There is a gap between the image and the glass, as in the case of the one illustrated, forming a narrow shelf.

You can buy such frames ready-made or have one made specially, to your measurements, by a picture framer.

To bond the toys permanently, use a strong all-purpose glue; for a more temporary display, use double-sided tape or a spray adhesive that allows for repositioning.

HERE, A COLLECTION OF CHILDHOOD PORTRAITS IS COMPLEMENTED BY A LINE OF PLASTIC FIGURES, ARCHERS AND KNIGHTS – WHICH ALSO FEATURE IN ONE OF THE PICTURES.

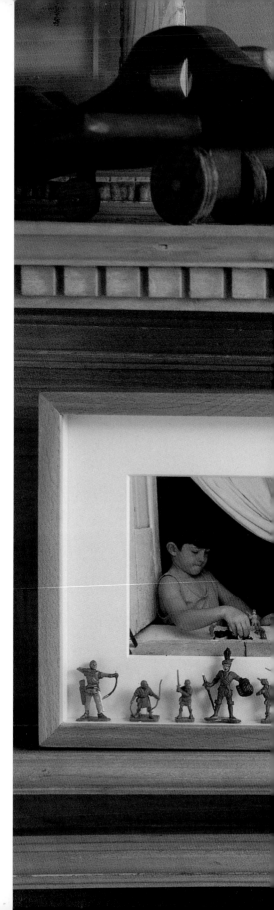

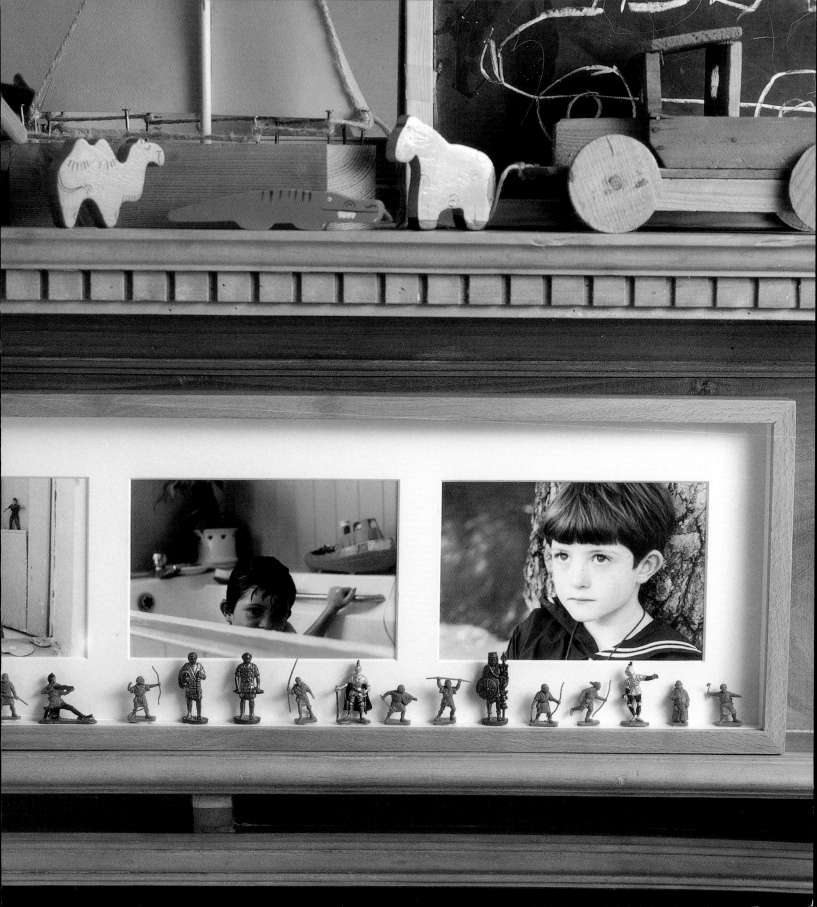

Picture Shelf

A set of small shelves is just the thing for displaying small ornaments, toys and other collectibles. Shelves like this can be bought from furniture shops and markets. Look out also for old printers' trays, once used to store metal type, or even cutlery drawers with several partitions.

Customize your shelves with pictures for a really personal touch. Here, pictures of a child at various ages form a backdrop for her small toys and trinkets. Pictures of pets, flowers or scenery might complement a set of ornaments.

Measure each section and cut pictures to size, sticking them in place with a strong all-purpose adhesive.

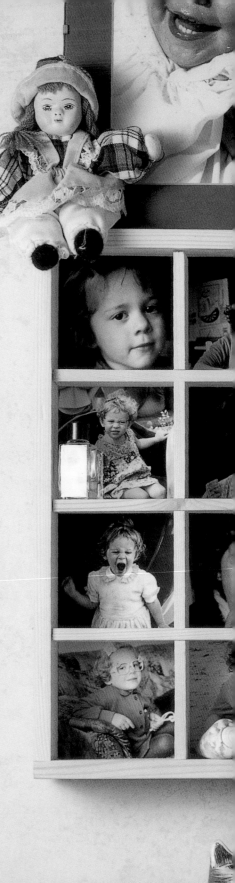

ANY CHILD WILL DELIGHT IN A SPECIAL SET OF SHELVES ON WHICH TO DISPLAY TINY TRINKETS.

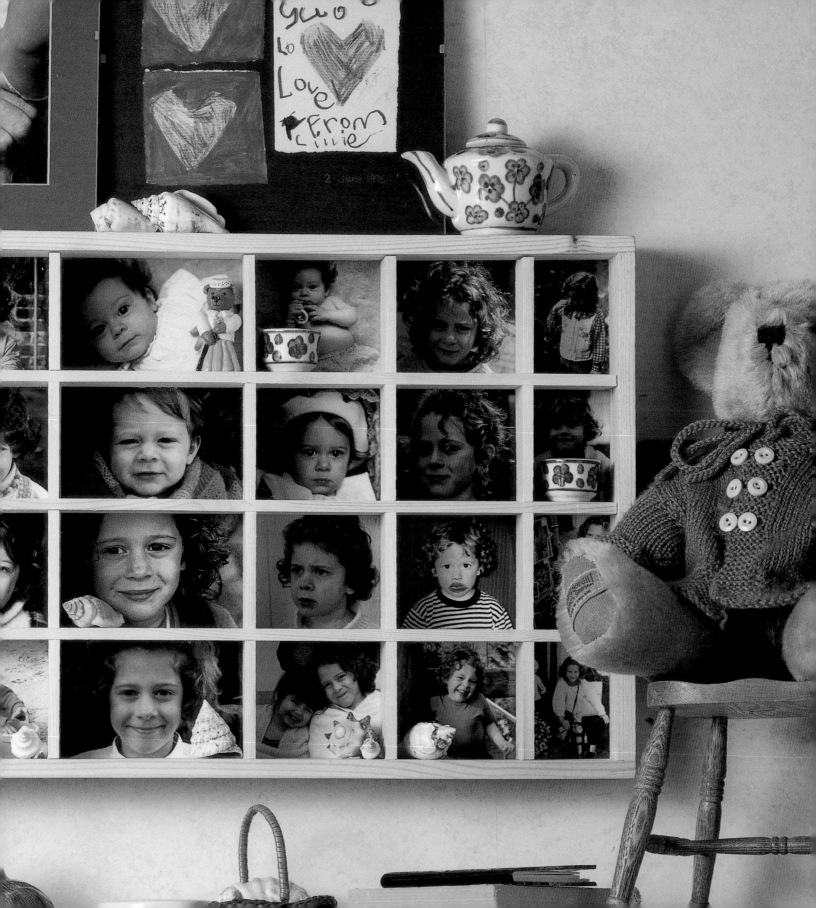

Collage

Why have just one picture when you can have many? Collage – a composition made from many images – and découpage – decorating with pictures – are great ways to use photographic images to striking effect.

Family Collage

Instead of hiding the family snaps away, buy the biggest frame you can find, fill it up, and put them on display!

If you have sorted through your snaps without finding a single picture worthy of its own special frame, this is a great way of using up second-best pictures, as together they combine to make a fascinating, visually rich effect.

Play around with various combinations, trimming pictures where necessary, until you are happy with your arrangement, then stick the pictures down on a piece of backing paper cut to the same size as your frame. Use a spray adhesive specially designed for mounting photographic prints, small pieces of double-sided tape, or a glue stick.

A PHOTO MONTAGE IS A GREAT WAY OF DISPLAYING A DIVERSE ASSORTMENT OF FAMILY SNAPS.

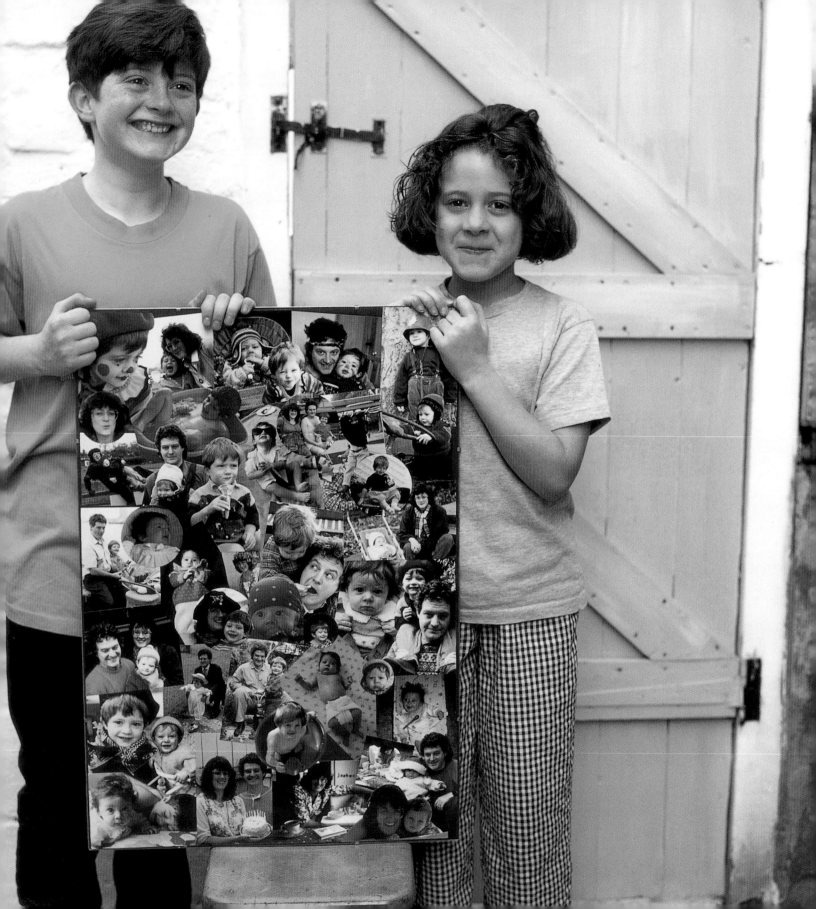

Découpage Box

Embellish a plain box with a favourite photograph and frame it with paper scraps. Elaborate scraps like these can be bought from craft shops and are available in a wide choice of designs. Many are reproductions of the scraps produced in Germany, America and England in the mid-nineteenth century when découpage was a popular pastime.

Here, because the photograph already included flowers, Victorian floral designs were chosen for a really romantic effect. The box itself was a gift box already covered in pretty gold paper. You could use any small box and cover it in decorative paper following the method described on page 14, before adding your photograph and scraps.

A BOXFUL OF MEMORIES – THE PERFECT CONTAINER FOR PHOTOS, LETTERS AND PRIVATE MEMENTOES.

Materials & Equipment

gift box with lid
paper scraps
PVA glue
polyurethane gloss varnish
small pointed scissors

I Trim your photograph if necessary. Coat the back with PVA glue and stick in place in the centre of the box lid.

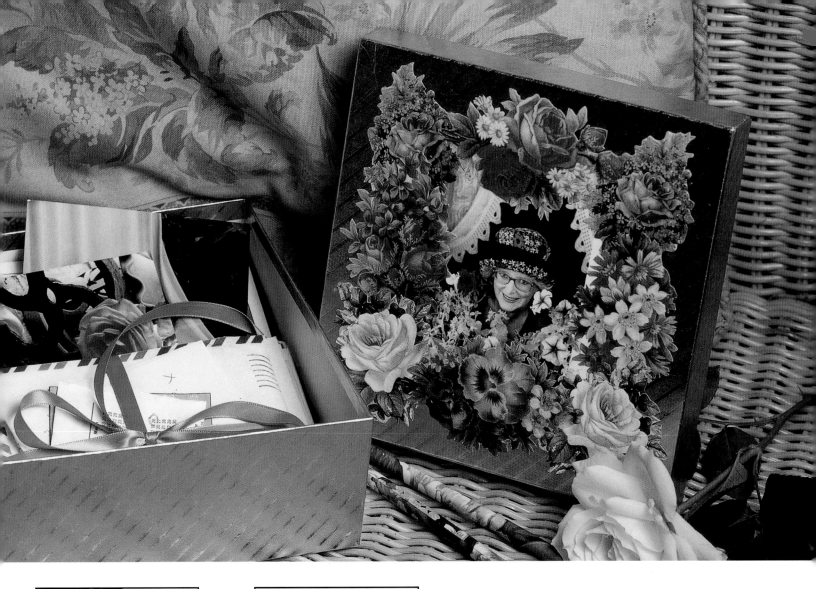

2 Cut out scraps using small, pointed scissors. Position them, and reposition until you are satisfied with the arrangement, then glue in place using PVA glue.

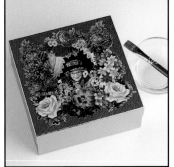

3 Protect the design by brushing all over with several coats of polyurethane gloss varnish.

Fabric Collage

Take a photograph as your central image, use a sewing machine to attach it to a fabric background, then build up layers of various fabric and other scraps into a unique collage. Experiment, using more than one picture, if you prefer, and finish off your creation with an off-the-peg frame.

Here, a wedding photo has been given a border of coloured fabric scraps and flowers, under a veil of netting. The flower shapes are made by dismantling fabric blooms and separating them into individual petals.

A BORDER OF FLOWERS, FABRIC AND NET IN SOFT, PRETTY PASTEL SHADES IS AN IDEAL TREATMENT FOR A PRECIOUS BLACK AND WHITE WEDDING PHOTO.

Materials & Equipment

medium-weight interfacing
fabric scraps
fabric flowers
lace
net
pencil
scissors
sewing thread
sewing machine

Step-by-Step

1 Cut a piece of interfacing 2.5cm (1in) larger than you want your finished picture to be. Place your photograph in the centre and draw around it in pencil, to mark its position.

2 Cut fabric into small pieces and stitch them to the interfacing, one at a time, using a zigzag stitch to cover raw edges, until the outer border has been covered.

3 Position fabric flowers and leaves on the fabric border then lay a piece of sheer fabric or net on top. Stitch the net in place, trapping the flowers beneath.

4 Stitch the photograph in position and stitch a length of lace all round.

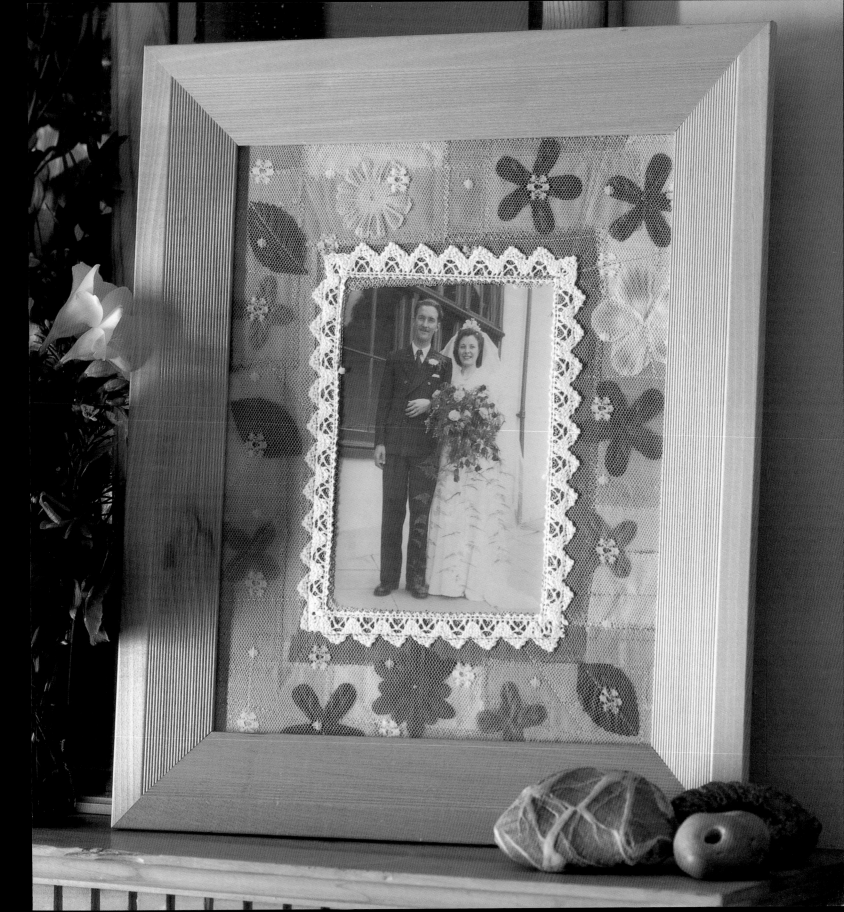

Decorated Tray

A plain wooden tray can be customized to display a collection of photographs under glass. Get a piece of glass cut to fit the inside of the tray and make sure the edges are bevelled smooth for safety.

A project like this one gives real scope for your imagination. Why not choose a selection of holiday pictures with a sky-blue border dotted with clouds? Or a montage of horticultural photographs with a flower-stamped border.

The choice of rubber stamps available in craft shops is overwhelming so you will almost certainly find one to suit your chosen theme. This method can be adapted to other pieces of furniture, as it would work on most smooth, horizontal surfaces and is a great way to jazz up a junk shop find.

A NUMBER OF PICTURES WITH A LINKING THEME – SUCH AS THESE CATS – MAKES A NOVEL DECORATON FOR A SIMPLE WOODEN TRAY.

Materials & Equipment

plain wooden tray
fine sandpaper
gesso or flat latex paint
craft paints or acrylics
masking tape
rubber stamp and ink pad
glass
silicone sealant
strong spray adhesive
water-based matt varnish

Step-by-Step

1 Sand the tray, if necessary, to remove any varnish or paint. Mark out and mask off the area where the pictures are to be stuck, then paint the edges of the tray with gesso or flat latex, followed by a coat of coloured craft or acrylic paint.

2 When the paint is dry, add a border design using a rubber stamp. Protect paintwork with several coats of varnish.

3 Stick the pictures in position using a strong, permanent spray adhesive. Drop the glass into position then seal all around the edges with a clear sealant.

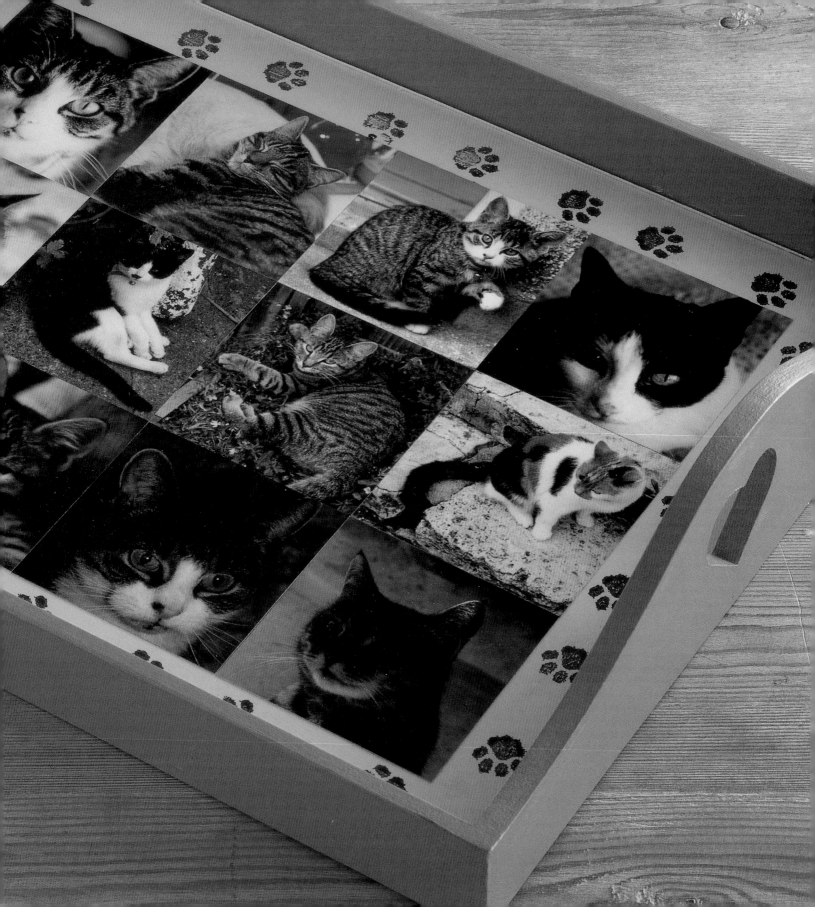

Letter Rack

Découpage – the craft of decorating with paper cutouts – is best done with images printed on fairly thin paper. It is therefore advisable to get colour photocopies of your chosen pictures which can then easily be cut out with small, pointed scissors, stuck in place and given several coats of protective varnish for a really professional finish.

This letter rack, once plain varnished wood, was simply sanded and sprayed with a water-based paint before being decorated. Family portraits and used postage stamps are an appropriate choice for the piece, which holds stationery, stamps and an address book. They were stuck in place with diluted PVA glue.

Before varnishing, it is advisable to brush over the paper decorations with a coat of diluted PVA. This seals them and prevents the varnish from soaking into the paper and discolouring the images.

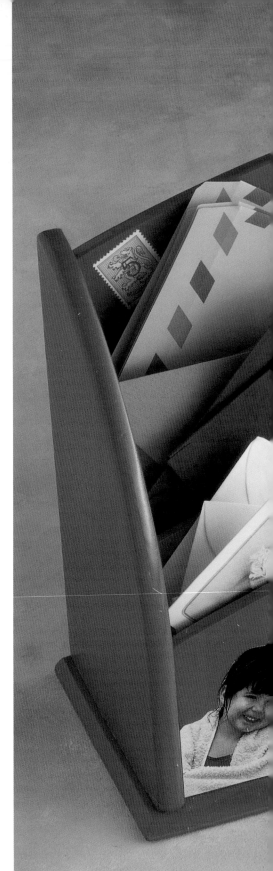

WITH THEIR PORTAITS ON PERMANENT DISPLAY, A PERSONALIZED LETTER RACK IS A CONSTANT REMINDER TO WRITE TO LOVED ONES.

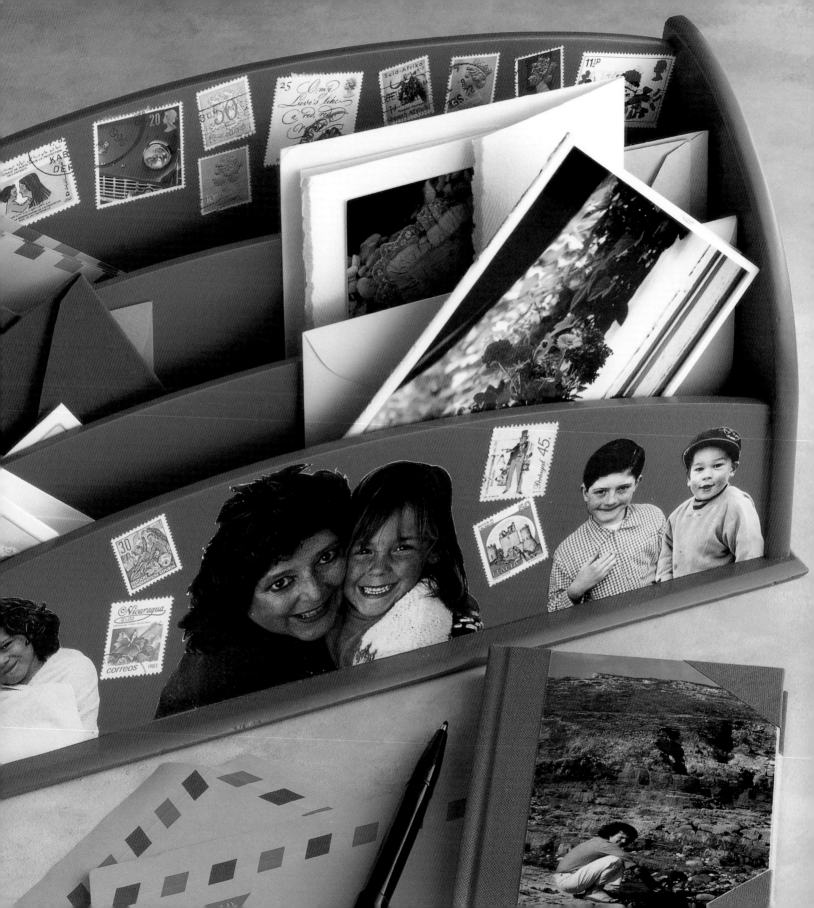

Treasure Boxes

Sometimes it can be very satisfying to make something out of virtually nothing. Here, wooden cigar boxes, painted and then decorated with photographs, make little treasure chests.

Tobacconists will generally be pleased to give away empty boxes. Just remove the paper labels by sponging with water and peeling off – or leave them in place if you prefer. Paint the box, inside and out. Cut prints to size and stick them on with strong spray adhesive or an all-purpose adhesive recommended for sticking paper to wood. When the glue is dry, give the whole box a coat of gloss varnish to finish and protect it. If you prefer to use photocopies, stick them in place with diluted PVA glue, brush over the top with more glue and, when dry, finish with a coat of matt varnish.

MOST CHILDREN WOULD TREASURE A BOX LIKE THIS. THEY COULD EVEN MAKE ONE FOR THEMSELVES. THE PALE GREEN BOX, RIGHT, FEATURES A MONTAGE OF PHOTOGRAPHIC PRINTS. THE TWO BOXES, BELOW, ARE DECORATED WITH COLOUR PHOTOCOPIES.

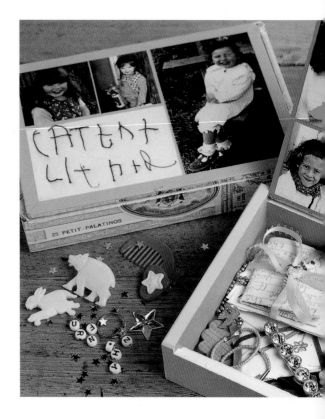

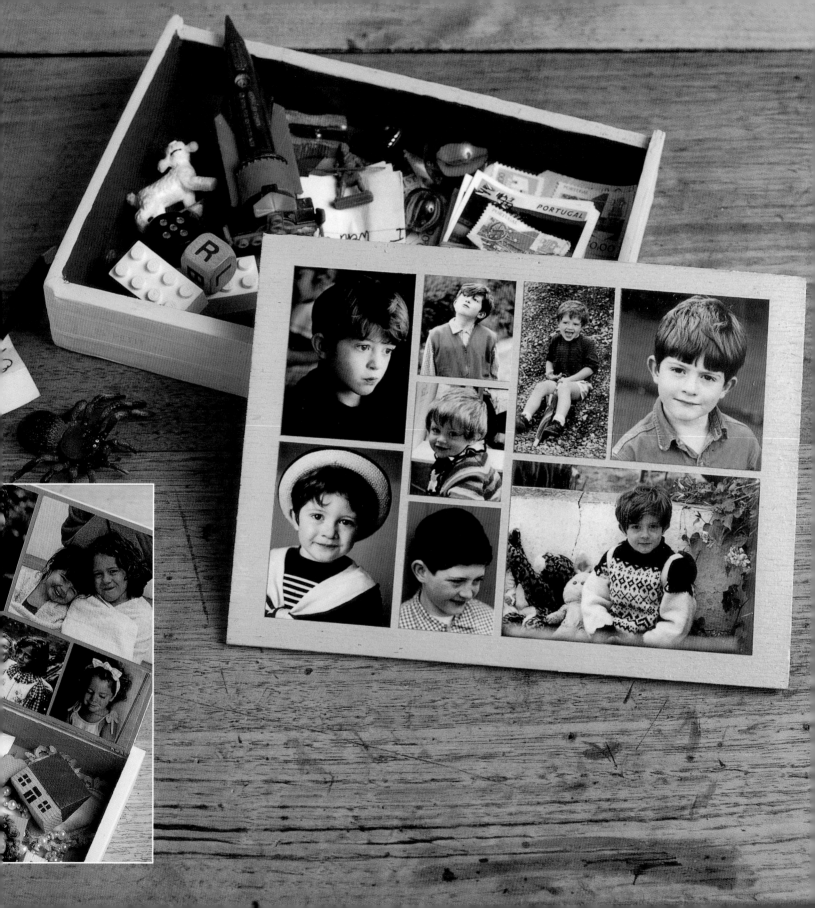

Découpage Chest

Here is a great way to recycle a piece of furniture that has seen better days. Whether it s a piece you've had for a while and were thinking of throwing out, or someone else's cast-off discovered in a junk shop or flea market, the découpage treatment will give it a whole new lease of life.

If the piece you select is already varnished or painted, be sure to sand it thoroughly before painting. This not only gives a smooth surface but helps the paint to adhere. If the surface is not properly prepared before you paint it, then the paint might flake off later, ruining your handiwork. This method can be used on brand new pieces of furniture, too, of course!

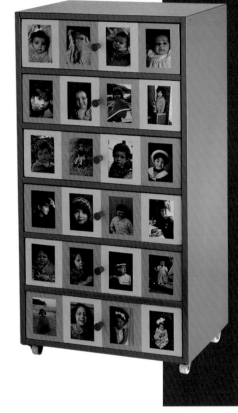

THE CHEST OF DRAWERS PICTURED HERE WAS SOLD AS OFFICE FURNITURE BUT HAS BEEN CUSTOMIZED WITH A SELECTION OF CHILDREN'S PORTRAITS AND BRIGHTLY COLOURED CRAFT PAINTS.

Materials & Equipment

chest of drawers
gesso or flat latex paint
sandpaper
craft paints or acrylics
masking tape
ruler
pencil
craft knife
varnish

1 Paint the front of the drawer with gesso or flat latex and, when dry, with one or two coats of yellow acrylic. Allow to dry.

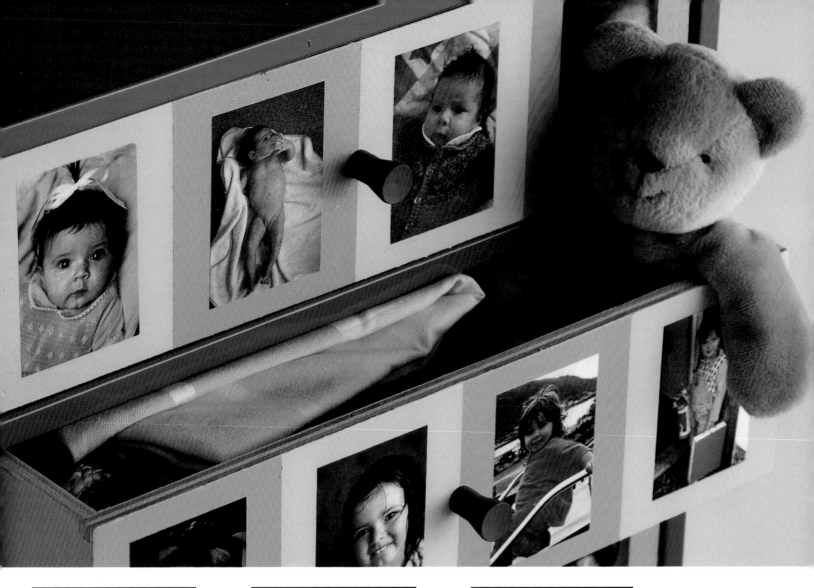

2 Measure and mark out divisions using a pencil and ruler, then mask areas that will remain yellow with masking tape. Paint over the edges of the tape with yellow paint; this seals the edge of the tape, preventing the green paint from creeping underneath. Leave to dry.

3 Paint unmasked squares with green paint. When the paint is dry, carefully peel off the tape.

4 Trim photocopies to size and stick in place with diluted PVA glue, smoothing carefully to remove air bubbles and ensuring that the edges are stuck down firmly. Brush over with more glue; this seals the pictures and stops them being stained by the varnish. Finish with several coats of varnish. Replace the handles or knobs.

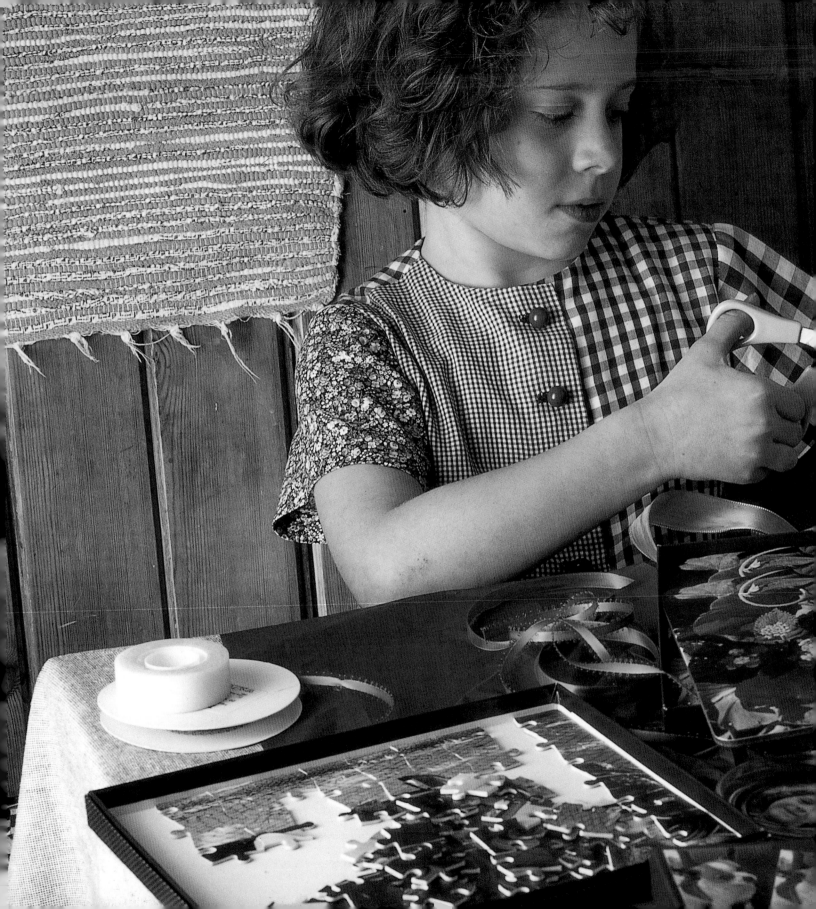

Original Gifts

One of the great things about photographs is that they can easily be reproduced and therefore shared. Turn some of your favourite pictures into very special personalized gifts.

Key Fobs, Coasters

Many craft shops sell plastic blanks ready to fill with your own pictures. These are often used to display needlework but are equally suitable for photographs, and they make great gifts for friends and family.

Look out for key fobs, luggage labels and drinks coasters, all of which are inexpensive and make perfect gifts. Just cut your chosen photographs to size, place in position and press the two halves of the item together, sealing the picture inside.

The cork mats were made using colour photocopies and the découpage method described on page 78.

Why not make up a set of six coasters, each with the same picture or different pictures on the same theme?

CARRY AN IMAGE OF YOUR FAVOURITE CHILD ON A PICTURE KEY RING.

LAY A DECORATIVE TABLE, RIGHT, WITH PHOTOGRAPHIC TABLE MATS AND COASTERS. THE SQUARE MATS ARE A SPECIAL SERVICE OFFERED BY SOME COMMERCIAL PHOTO PROCESSORS.

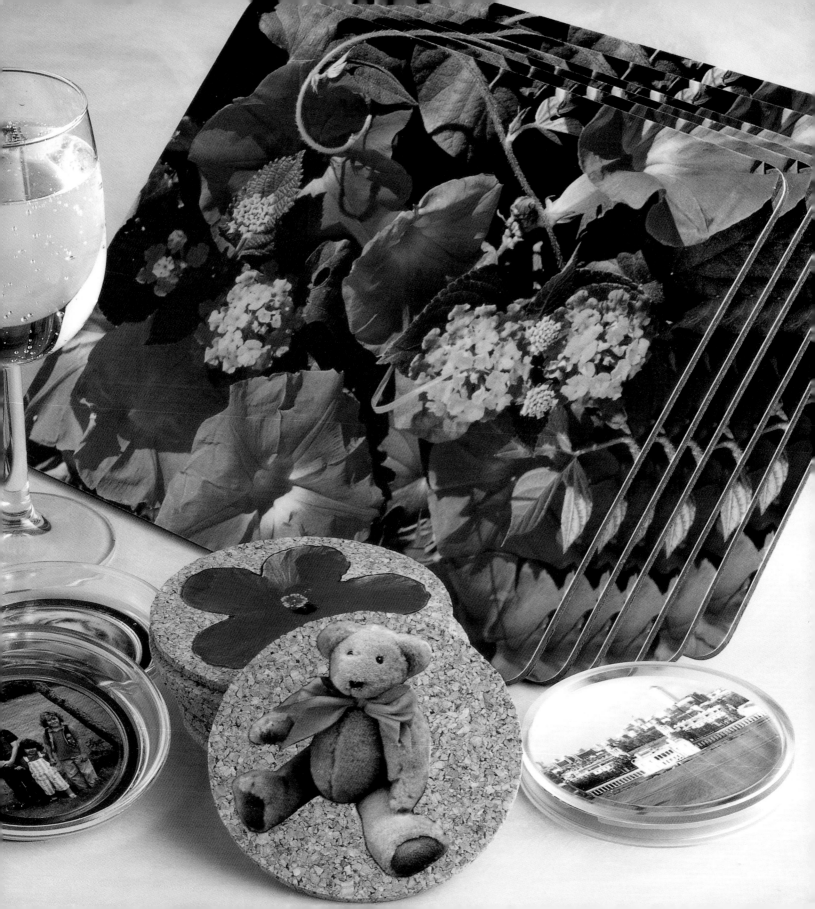

T-shirts

Stand out from the crowd with a favourite photograph emblazoned across your chest.

Mass-produced picture T-shirts and clothing with ubiquitous fashion logos become commonplace when compared to your very own, one-off designer original.

Of course there is no need to stop at just one personalized T-shirt. You could make yourself a whole photo wardrobe, with pictures of yourself, friends, family, pets – or whatever takes your fancy.

Use the method described on page 28 to transfer images on to clothing, or, for quick results, take your photographic prints along to a photo processor or copy shop that offers a T-shirt printing service. Some even make teddy-sized T-shirts.

IT'S FUN TO WEAR A PICTURE OF YOURSELF AS A BABY – AND PHOTO T-SHIRTS OPEN UP MANY OTHER DESIGN POSSIBILITIES.

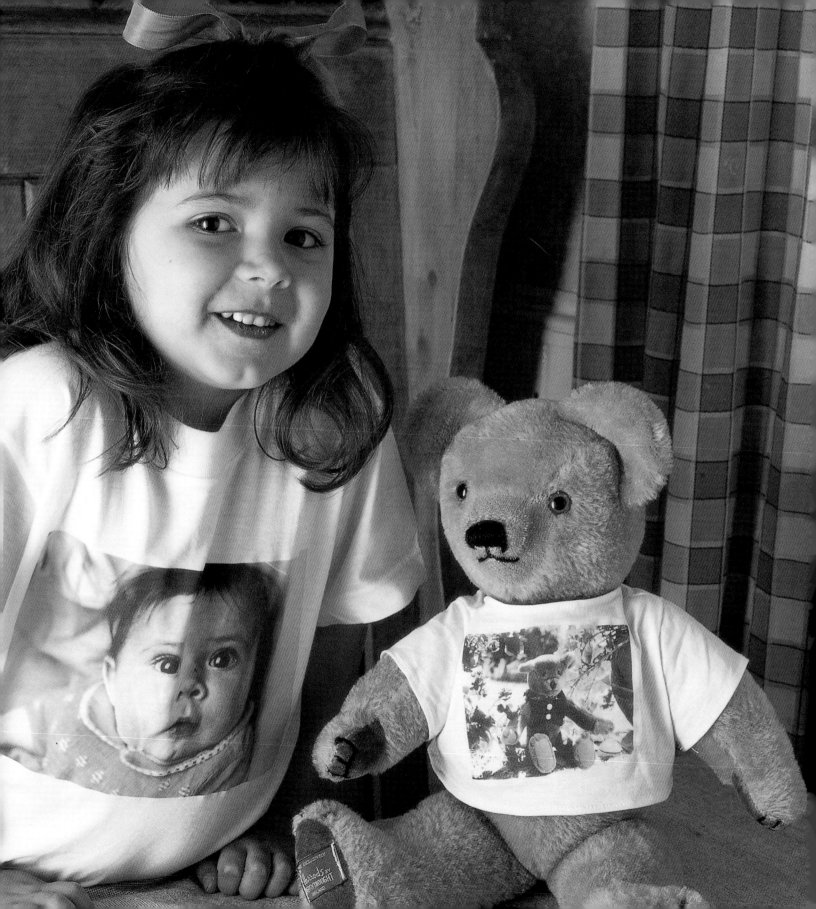

Jigsaw Puzzles

It's very easy to make your own jigsaws. Either mount your chosen photograph (or colour photocopy) on thick cardboard and cut into pieces using a craft knife and steel ruler, or stick it on to plywood and cut up using a jigsaw.

Put the pieces into a box and stick a copy of the photo on the lid, as a guide to completing the puzzle.

If you are making a jigsaw as a gift for a child, cut it into a suitable number of pieces: just a few for a toddler of three years or younger, maybe a dozen pieces for a preschool child, and a greater number of more intricate pieces for an older child.

For a jigsaw book, mix and match pictures to make composite characters. Choose a number of pictures and trim them all to the same format, then stick on to coloured cardboard, to make pages. Get them ring-bound – many photocopy shops or office suppliers provide this service – then cut into three sections, using a ruler and craft knife.

CHOP UP SOME FAVOURITE PICTURES TO MAKE A NOVEL JIGSAW OR PHOTOFIT PUZZLE BOOK – FOR VERY ORIGINAL GIFT IDEAS.

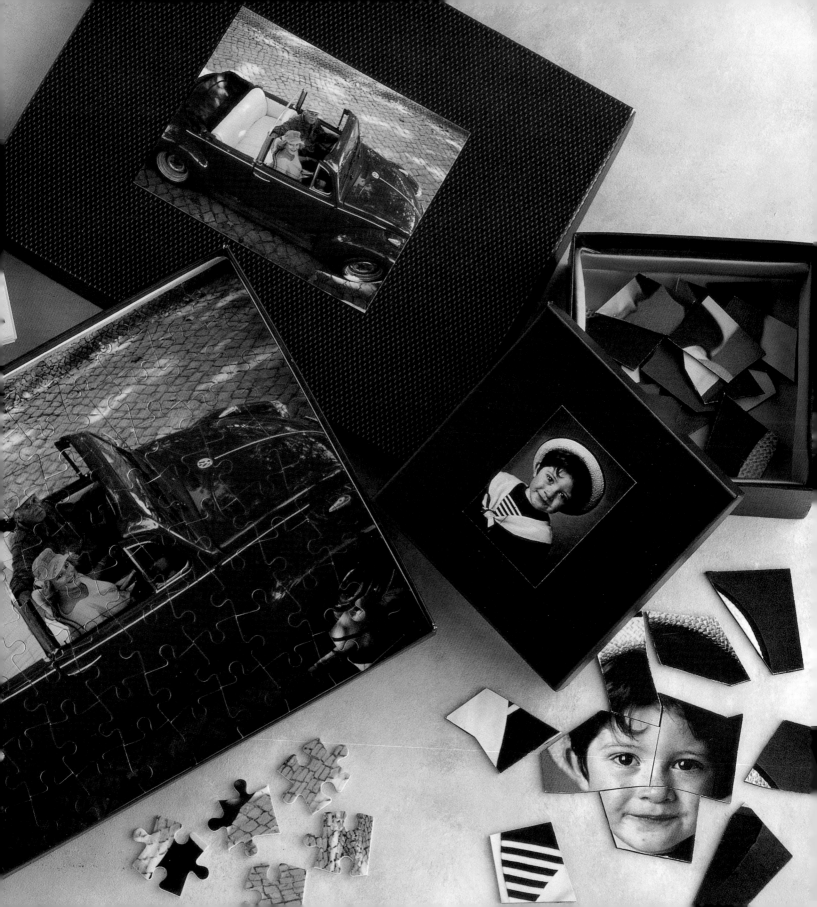

Matching Pairs

As well as enlargements, you can often get small-scale prints made – great for keeping in your wallet. (See Print Formats on page 124.) Use these small prints, or pieces cut from larger prints, to make a matching pairs card game.

A BOXED SET OF MATCHING PAIRS CARDS MAKES AN INTRIGUING PRESENT FOR AN ADULT OR A CHILD.

To make this game, you will need two copies of each image. Choose a theme – such as animals or flowers – or just have a random selection. Even abstract shapes or leftovers are suitable.

The cards can be used to play snap, pair-matching or a memory game, where all the cards are turned face down and two or more players take turns to turn two face up. If they match, the player keeps them and has another turn. If they don't, the cards must be turned face down again, and the players try to remember the positions. The winner is the player with the most pairs at the end of the game. Type out these rules of play and include them in the box.

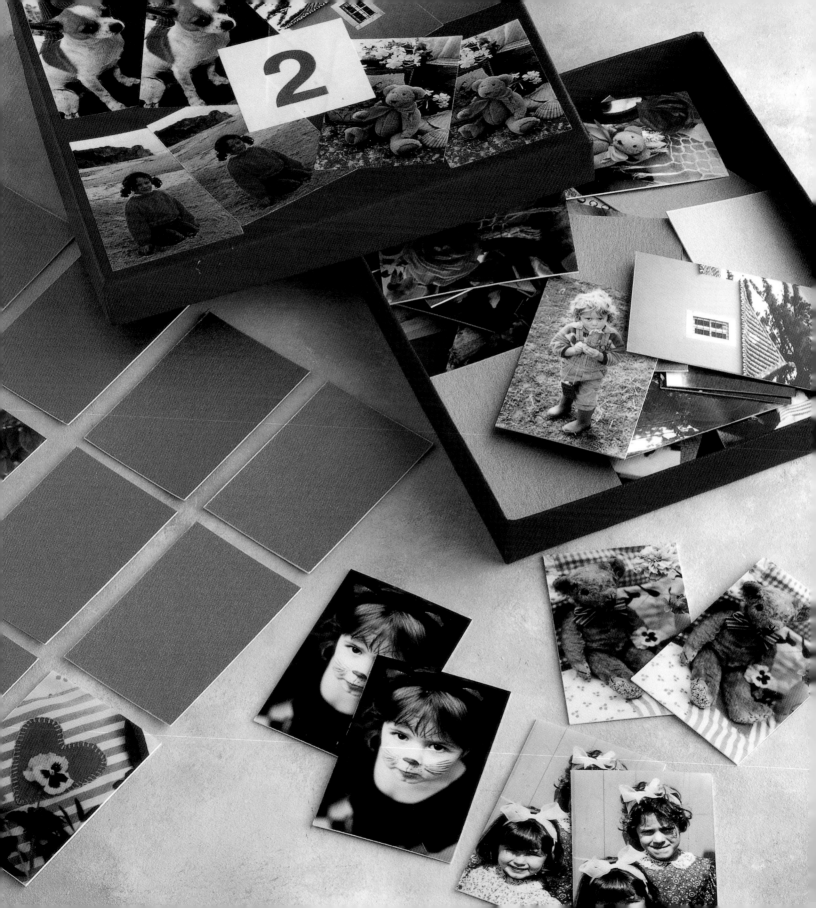

Bookmarks, Calendars

To mark your place in a diary or any book, make a photographic bookmark. Use a strip of contact prints, or choose a tall, narrow composition.

For a pocket calendar, just the right size to slip into your handbag, glue a small print on to the cover of a calendar pad. Or stick the picture on the inside of the cover, punch a hole in the top and hang up.

Look out also for mail-order companies that offer a calendar-making service, where you send a selection of prints to have made up into a calendar. Some shops sell blank calendars, too, printed with dates but with spaces left for you to add your own pictures.

You can, of course, easily make your own calendars. Use an existing one as a template, or make up pages on a computer, if you have access to one. The simplest method of all is to place a single photo in a cardboard mount and stick on a calendar pad, available from stationers.

A POCKETFUL OF PICTURES ... TUCK A PHOTO BOOKMARK OR TINY HOME-MADE CALENDAR INTO YOUR DIARY OR POCKETBOOK.

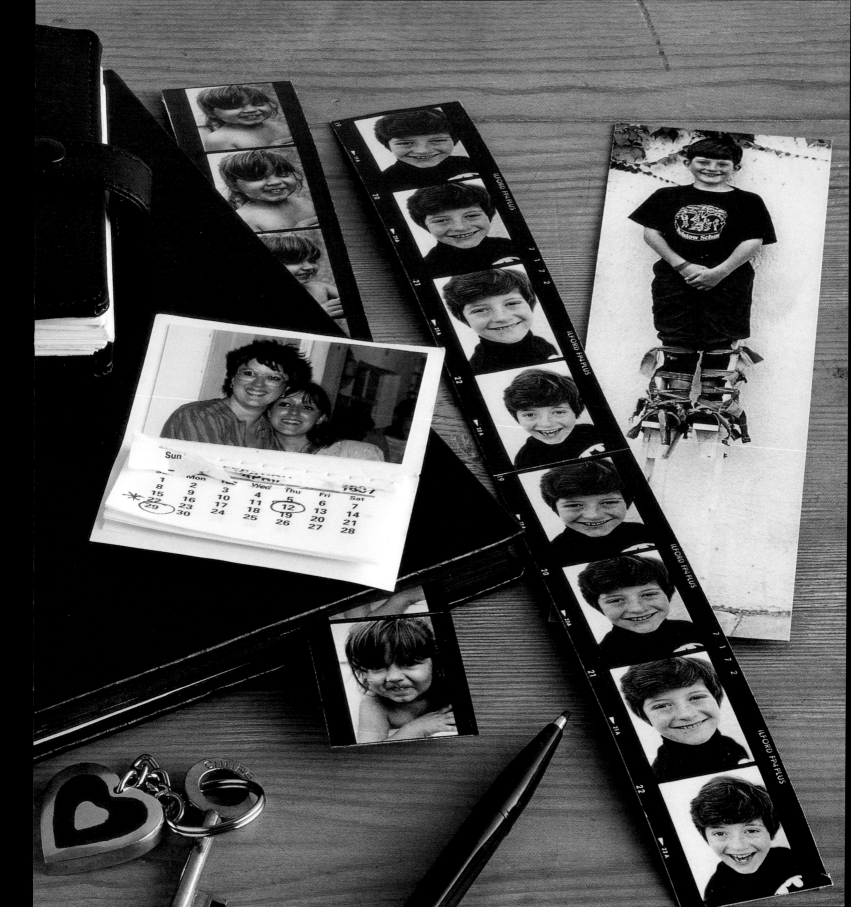

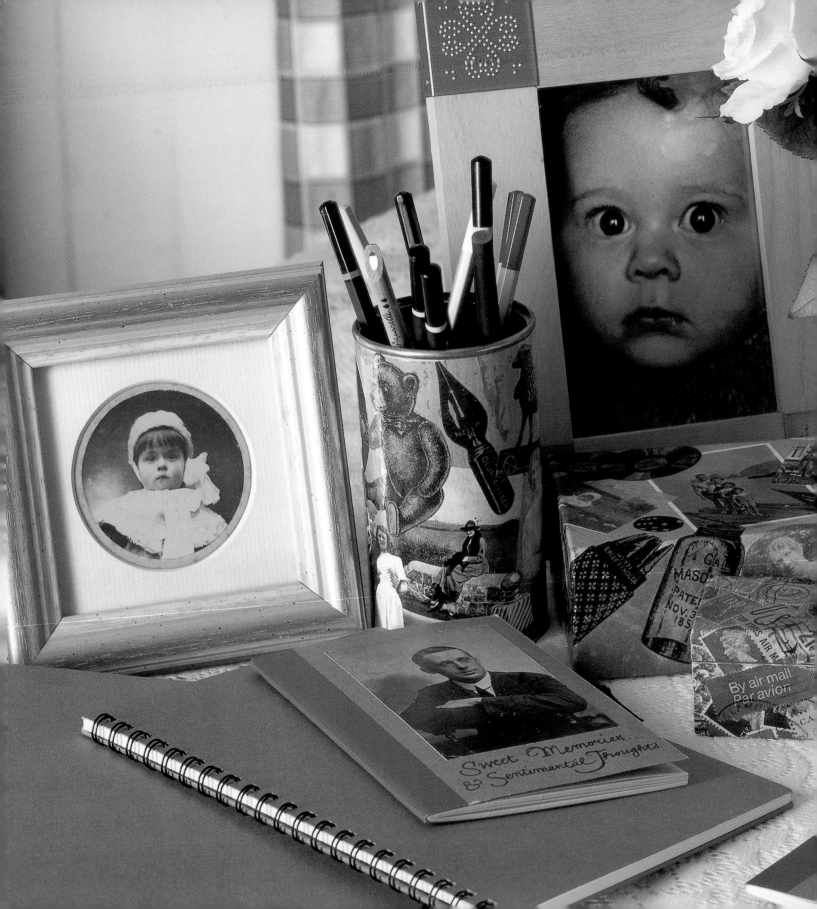

Sweet Memories... & Sentimental Thoughts

Special Occasion Stationery

Add a really personal touch to special occasions, birthdays, Christmas and other festivities by using photographs to create cards, invitations and decorations.

Birthday Celebration

When you want to celebrate in style, make the party really special with handmade invitations, personalized place cards and bunting. Here's an idea for a 40th birthday bash that could easily be adapted for an anniversary, engagement or retirement party.

Invitations, place cards and bunting have all been made using colour photocopies. Choose photographs, past and present, of the guest of honour, and stick them on coloured paper, then take them to your local copy shop.

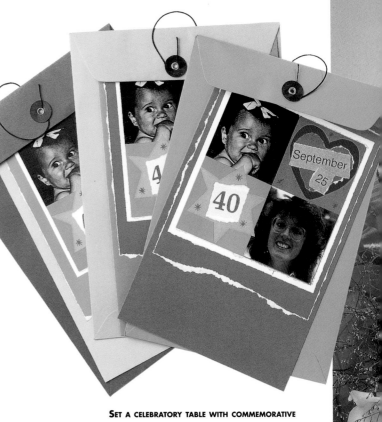

SET A CELEBRATORY TABLE WITH COMMEMORATIVE NAME CARDS, AND DRAPE WITH FESTIVE BUNTING.

PLACE CARDS CAN BE PERSONALIZED WITH GUESTS' NAMES.

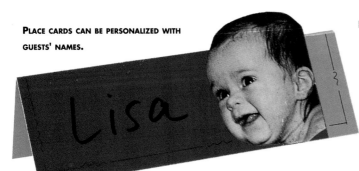

Materials & Equipment

A4 paper
glue stick
coloured cardboard
craft knife
pencil
ruler
scissors
string

I For economy, try to fit all your artwork on a single sheet of A4 paper: invitation, place card and bunting. Make the same number of colour copies as there are guests at the party.

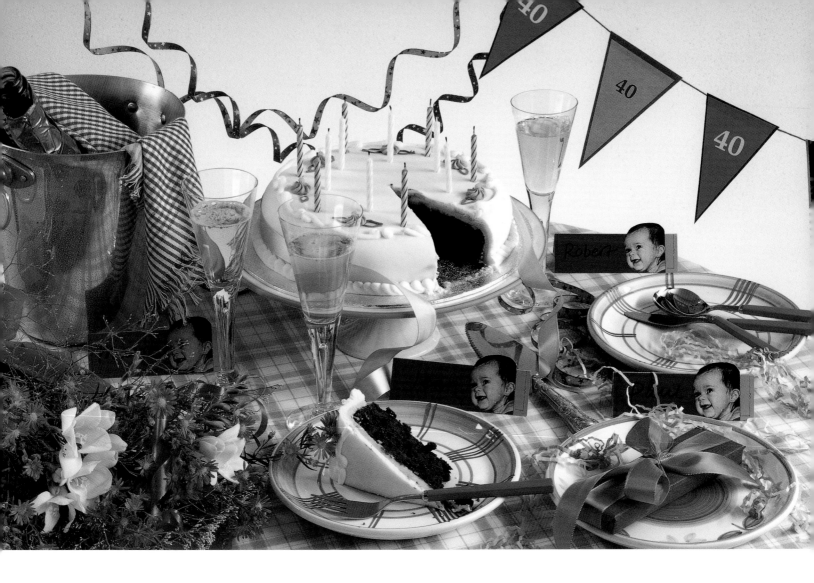

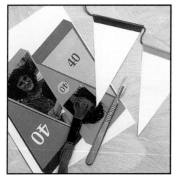

2 Cut up colour photocopies with scissors or a craft knife. To make bunting, fold the top of each flag over a length of coloured string and stick in place with glue or double-sided tape.

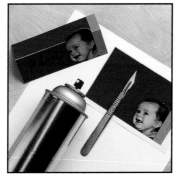

3 To make place cards, mount photocopies on to thin cardboard. Score along centre line to make a clean fold – but cut around the edges of images that appears above this line, to make a cut-out shape.

Greetings Cards

We send each other cards on all kinds of occasions and the selection available to buy is enormous and varied. For some people, however, there is nothing more special than to receive an original, hand-crafted card, made with love.

When time is short, simply stick a photograph on a folded card. By keeping a supply of pre-cut cards, with or without an aperture – a window cut in the centre – to frame your chosen photograph, you can easily put together a professional-looking card at short notice.

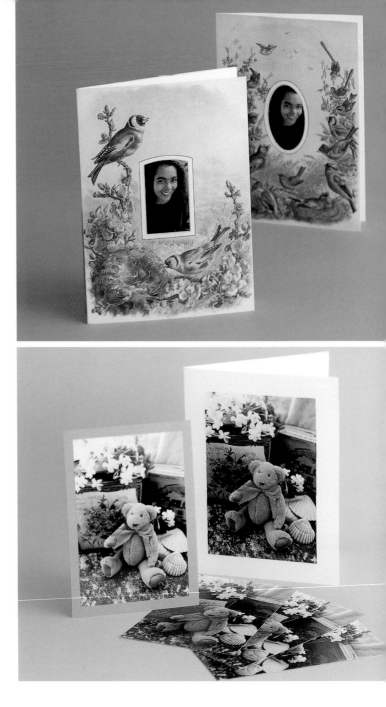

TOP: THESE PRINTED CARDS WITH READY-CUT APERTURES MAKE PERFECT FRAMES FOR FAMILY PORTRAITS.

BOTTOM: IT'S EASY TO MAKE AN EDITION FROM A SINGLE PRINT FOR A GREETINGS CARD OR INVITATION – JUST USE COLOUR PHOTOCOPIES.

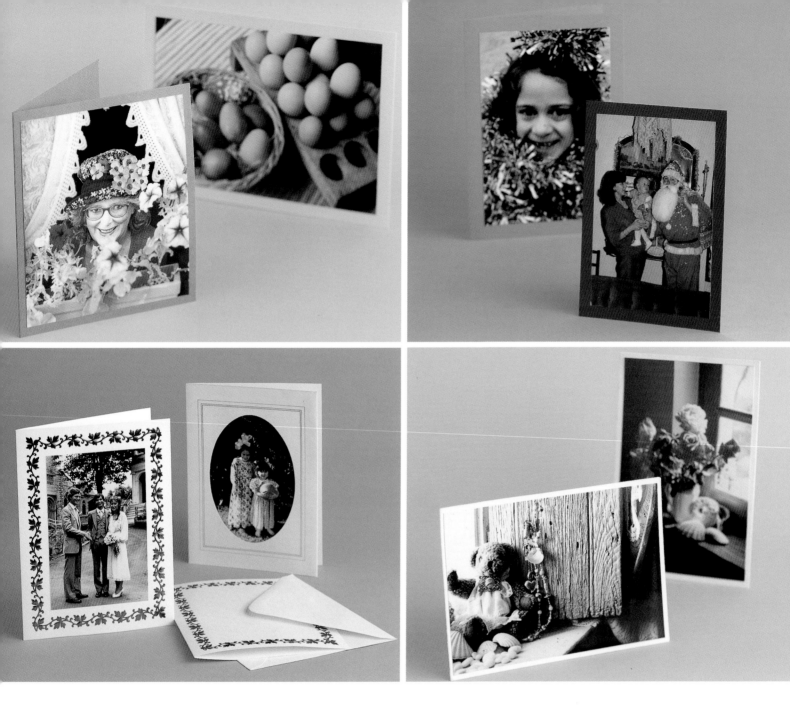

TOP: A HAT DECORATED WITH FLOWERS OR A STILL-LIFE PHOTO OF EGGS – HOMEMADE CARDS ARE MORE PERSONAL THAN SHOP-BOUGHT EASTER CARDS.

BOTTOM: LOOK FOR BLANK CARDS WITH A PRINTED BORDER, OR DECORATE A PLAIN CARD YOURSELF, USING A RUBBER STAMP, STENCIL OR FREEHAND DESIGN.

TOP: PERSONALIZED CHRISTMAS CARDS ARE FUN AND CAN BE KEPT AS A SPECIAL SOUVENIR OF FAMILY OCCASIONS.

BOTTOM: MAKE A POINT OF TAKING PICTURES WITH GREETINGS CARDS IN MIND. SEARCH FOR SUITABLE SUBJECTS – A VASE OF FLOWERS OR A TEDDY, FOR EXAMPLE.

Cards

If you have a bit more time to spend on card-making, experiment with combinations of photographs, plus pictures cut from magazines, stickers and other materials. Doilies, scraps, and coloured wrapping papers can all be used.

Experiment with different shapes, textures, patterns and colours and add strings or ribbons as a finishing touch.

Look out for unusual types of paper and cardboard. Handmade paper looks particularly effective if torn rather than cut. Metallic or holographic cardboard adds sparkle.

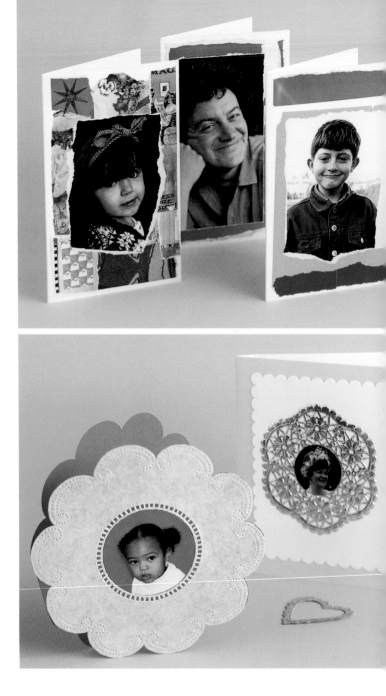

TOP: TORN PAPER SCRAPS AND PHOTOCOPIES MAKE COLOURFUL COLLAGE CARDS.

BOTTOM: CUT OUT PAPER DOILIES MAKE LACY FRAMES FOR PORTRAITS – A ROMANTIC CHOICE FOR A CHRISTENING, WEDDING OR ENGAGEMENT CARD.

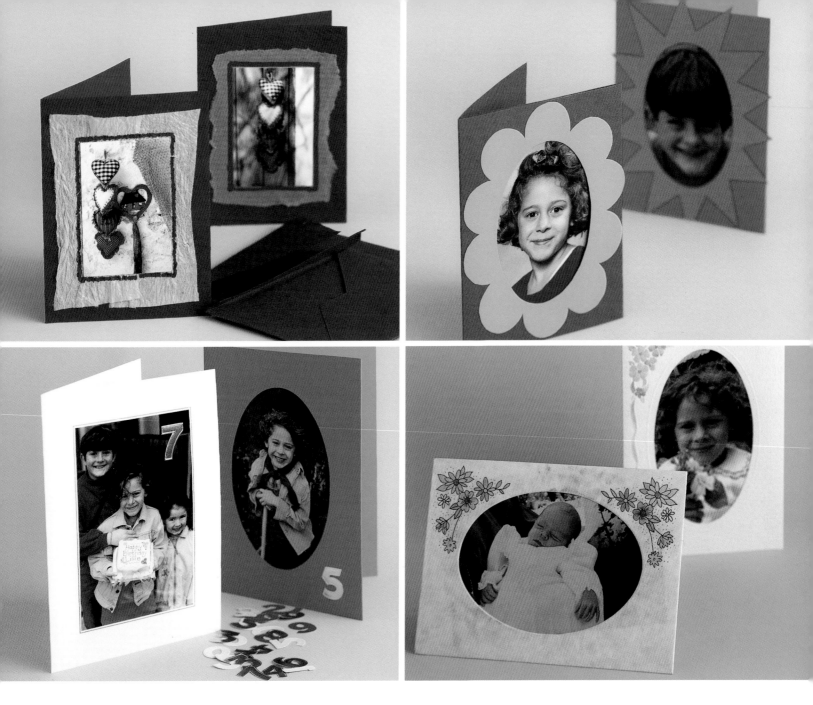

Top: Look for handmade and textured papers to form simple but effective backgrounds for photographic prints.

Bottom: For a personalized birthday card just add numbers to an appropriate picture.

Top: Add a splash of colour by cutting flower or star shapes from paper.

Bottom: Use your artistic skills to add a sprig of flowers to a plain or embossed card with watercolour paints or pens.

Gift Tags

A little time and trouble taken in wrapping a present makes all the difference. Make your gifts extra special with handmade gift tags.

You could use a picture of the recipient – particularly appropriate for a child who cannot yet read – or perhaps a visual clue to the gift inside.

Whatever picture you choose, you can be sure that your efforts will be appreciated and the labels will not be discarded with the other wrappings, but cherished.

Use ready-made tags, such as plain luggage labels, or make your own from leftovers of coloured cardboard.

Materials & Equipment

coloured cardboard
craft knife
steel ruler
punch
self-adhesive
reinforcing rings
ribbon or string
glue stick or
double-sided tape

HANDMADE TAGS ARE DECORATIVE (MAIN PICTURE) AND IF YOU USE A PICTURE OF THE RECIPIENT (RIGHT), SHE CAN SEE AT A GLANCE THAT THE GIFT IS INTENDED FOR HER!

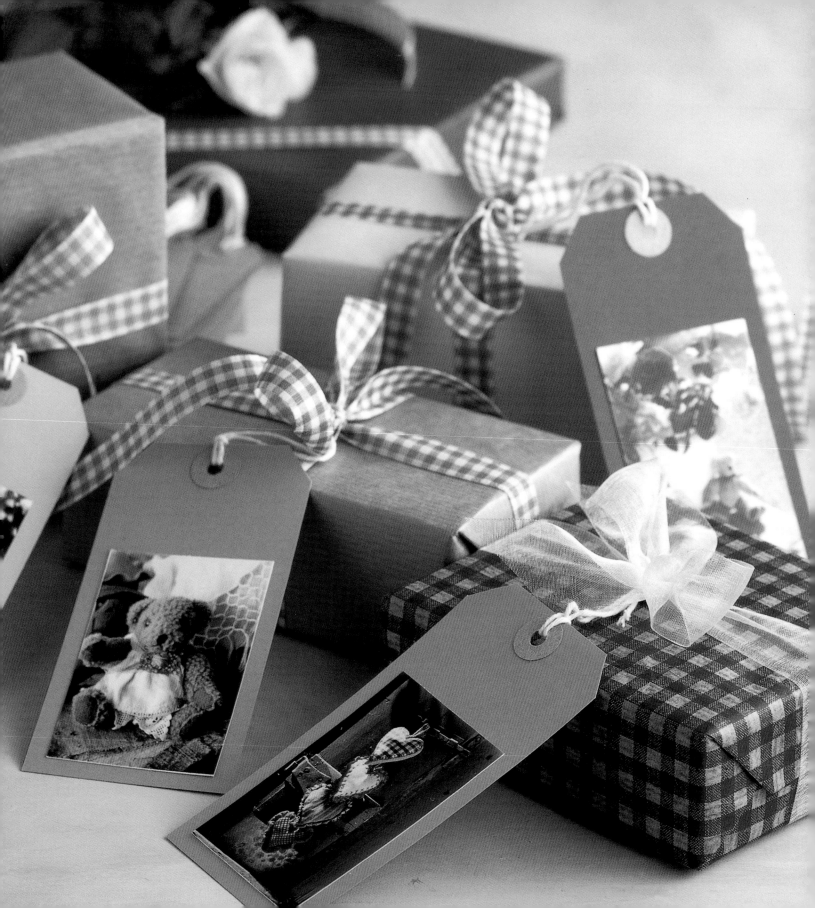

Stars

Use either photocopies or prints to make dazzling decorations. They are a good way of using leftovers from other projects – but if you want to make a number of stars with the same image you may need to have copies made and colour photocopies can work out less expensive than photographic reprints.

Cut stars from medium-weight plain, patterned or metallic cardboard, single or double-sided. Stick pictures in place with a glue stick or permanent adhesive spray.

Ideal as Christmas, birthday or Hallowe'en decorations, choose images to fit the occasion. Hang them from the tree or mantelpiece, scatter them over the side-board or dinner table, tie them to a parcel or pop them into party bags.

NEEDLEWORK AND CRAFT SHOPS SELL INEXPENSIVE PLASTIC FRAMES LIKE THESE TREE, BELL AND STAR SHAPES. USE THE FRAME ITSELF OR THE CARDBOARD BACKING AS A TEMPLATE FOR CUTTING PHOTOS.

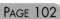

Personal Stationery

For a stationery set with a touch of nostalgia, use photocopies of old family photos combined with 'antique' scraps.

Like the dressing table on page 18, your desk is an ideal place not only to store your special stationery but also to display precious memorabilia.

Once you have made one or two items – a pencil pot or letter rack – there will be no stopping you! Just look around the house for items to embellish with special photographs – anything from a cocoa tin to a shoe box – or browse around your local stationer's for books and boxes that you can customize.

Revive the art of letter-writing with your own personalized paper, correspondence cards and envelopes. They are easy to create by making up a piece of artwork and having it photocopied, in black-and-white or colour, on plain or patterned paper.

COVER BOXES AND BOOKS WITH BROWN PAPER AND DECORATE USING SEPIA PHOTOS. IF YOU WANT TO PRESERVE ORIGINAL PRINTS, HAVE COLOUR PHOTOCOPIES MADE.

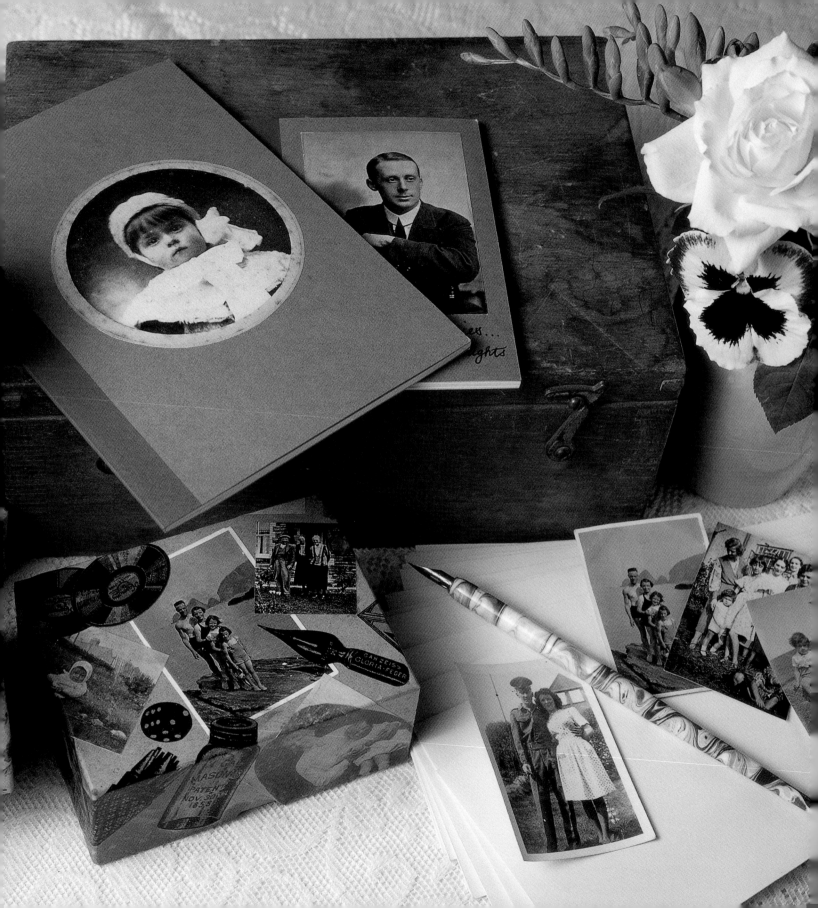

Taking Better Pictures

For most people, taking pictures is not a hobby but a normal part of life. On days out, special occasions and holidays we take along our cameras as a way of recording the event.

Over the next few pages, you will find tips for improving the resulting photographs. There is no technical information about cameras and lenses, no professional jargon. It is assumed that you know how your own camera works, how to load the film, and which buttons to press.

Whether you are using a compact, an SLR (single lens reflex) or a one-use disposable camera, the same basic principles apply.

All the photographs used to illustrate this chapter, as well as all the pictures used in making up the projects in the rest of the book, are just ordinary family photos, taken at home or on holiday, and nearly all were taken on a basic manual 35mm SLR camera with a 50mm lens.

Equipment, Film, Composition

It is not the camera which produces good photographs but the person who takes the picture. We are all capable of producing better photographs if we are prepared to spend time considering each shot before we press the button.

Whether you are using a point-and-shoot compact, a more sophisticated and controllable SLR or even a disposable camera, understanding a few basics will help to give you the confidence to take more interesting pictures.

Compact

This is the choice for most people, as it is inexpensive, easy to use, and uncomplicated. The essential selling point is automation: exposure, focus, film wind-on and flash are all taken care of. Some more sophisticated models also include a motorized zoom lens, useful for taking portraits without moving closer to the subject.

THE ATTRACTION OF A COMPACT CAMERA, FOR MOST PEOPLE, IS THE SIMPLICITY OF USE, WITH AUTOMATIC FOCUSING, FLASH AND OTHER FEATURES.

As many compacts are fitted with a wide-angle lens, however, they are best suited to landscape shots – ideal for holiday snaps – and for occasions like weddings and parties, where the built-in flash will cope with most lighting situations. For people pictures, the basic compact camera can only cope with full-length portraits.

35mm SLR

It is worth spending money on a camera that has interchangeable lenses and allows you to control exposures. With even the most basic SLR and a standard 50mm lens you will be able to take close-up portraits, weddings, still life pictures and action shots as well as holiday pictures. A zoom or telephoto lens will bring distant subject matter closer, allowing you to capture sporting action, too.

There are several types of SLR camera: manual, automatic and programmed automatic.

A BASIC 35MM SLR NEED COST NO MORE THAN A COMPACT CAMERA BUT ALLOWS MUCH MORE CONTROL AND CHOICE.

Automatic models set the exposure once the photographer has selected either the shutter speed or lens aperture (f-stop). Programmed automatics offer a choice of modes, such as shutter priority or aperture priority.

This simply means that you have more control over the degree of light entering the lens. By choosing a fast shutter speed, for example, you can freeze action; by choosing a wide aperture you can increase depth of field, ensuring that subjects are in focus even when they are at varying distances from the camera.

Advanced Photo System

With a range of compact and SLR models, APS cameras offer a choice of print formats, including panoramic prints, a

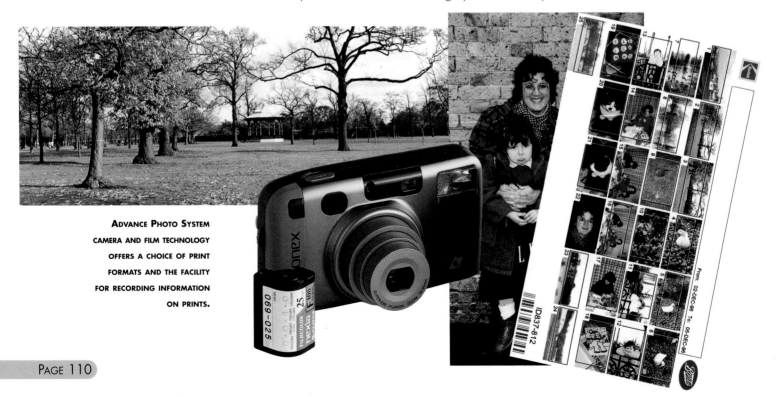

ADVANCE PHOTO SYSTEM CAMERA AND FILM TECHNOLOGY OFFERS A CHOICE OF PRINT FORMATS AND THE FACILITY FOR RECORDING INFORMATION ON PRINTS.

ready-made storage system and a contact sheet, which helps with cataloguing pictures and re-ordering prints. Otherwise, the pros and cons are the same as for other compact or 35mm SLR cameras, with a range of highly automated models offering various features, including automatic focus, flash, zoom lenses and a facility for labelling prints with date, time and title.

Instant camera

The great advantage of the instant camera is an immediate result. For extra flexibility, choose a model with an optional close-up facility.

Picture quality is sometimes disappointing but can be improved by following a few basic guidelines. For example, try to make sure the main subject is in the centre of the frame, and position people in front of a light coloured background. Avoid very bright lighting conditions indoors, and outdoors always try to have the sun behind you or to one side – not directly overhead.

THE DISAPPOINTMENT OF HIT-OR-MISS PICTURES IS FAR OUTWEIGHED BY THE INSTANT RESULTS.

Film

Choosing a film is partly a matter of personal preference – colour print, colour slide, black & white – and is partly governed by light conditions. Some films are better than others for certain subjects and conditions, and colour quality can vary from brand to brand. You will learn which film suits you best through trial and error but here are a few guidelines for you to consider.

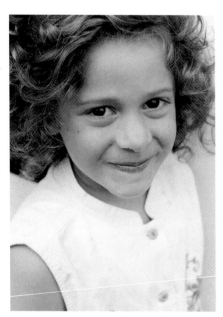

TRY USING BLACK AND WHITE FILM FOR A CHANGE, FOR EVERYTHING FROM LANDSCAPES TO PORTRAITS.

Fast film, with a rating of ISO 400 and above, is sensitive to light and perfect for taking pictures in conditions where the light is dim and you do not want to use flash. Slow film, ISO 100 or below, is the choice for bright conditions – sunny holiday snaps. Medium film, ISO 200, is somewhere in between the two.

Most cameras either read the film speed automatically and adjust exposures accordingly, or have a built-in light meter which requires you to adjust the film speed setting.

Keep film in its plastic lidded container to keep out dirt, and store it in a cool place. It is advisable to use film before its expiry date, and to process it as soon as possible after it has been exposed.

Composition

You do not have to travel far to take a good picture. There are interesting subjects all around. Before you even pick up your camera, get used to using your eyes. It sounds obvious but a camera frames a scene, which your eye and brain don't do. Photography is not really about capturing reality but rather about making two-dimensional pictures.

BY MOVING CLOSE TO A SUBJECT AND ISOLATING IT FROM ITS SURROUNDINGS, YOU CAN PRODUCE A PICTURE OF BREATHTAKING SIMPLICITY.

When you are ready to take the photograph, take your time. Again, this seems fairly obvious, but because modern cameras capture images quickly and without much effort, it has become so easy to 'snap' a photo that people get into the habit of not taking time to choose their subject carefully or to compose their pictures with a bit of forethought.

If possible, examine your choices before pressing the button. This can make the difference between a mediocre picture and one you'll want to put on display.

AT HOME OR ABROAD, YOU MAY ONLY NEED TO STEP OUTSIDE YOUR FRONT DOOR TO CAPTURE AN INTERESTING SCENE.

When using a compact camera, the picture you see through the viewfinder is not exactly what will be recorded on the film.

If you are not careful, you will be in danger of slicing off part of your subject. Some of the more sophisticated models compensate for this but with a basic compact it is always advisable to include a bit more of the surroundings than you need in your composition – you can always crop the print later.

TRY A VERTICAL FORMAT AS WELL AS A HORIZONTAL ONE (BELOW).

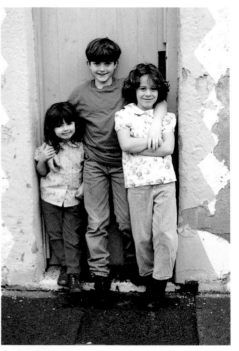

WHEN USING A COMPACT CAMERA, IT IS A COMMON MISTAKE TO CUT OFF THE HEADS OF YOUR SUBJECTS.

Formats

The camera doesn't need to be held horizontally. Although this may be the natural choice for many landscapes, try using a vertical format if it is right for the shape of your subject. A full-length portrait, a tree, a tall building, for example, may look much better as an upright picture.

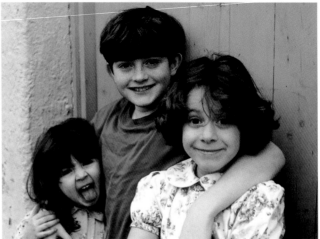

Filling the frame

One simple way to give a picture more impact is to get closer to your subject, so that it fills the frame. With people pictures, it may be a case of taking a few steps forward, while with some subjects – landscapes, sports – you may need to use a zoom lens if you cannot move physically closer.

If getting closer is just not possible, and the main subject remains small, try using some foreground detail to 'frame' your subject.

The best viewpoint

Sometimes by moving around your subject and thereby changing your viewpoint, you can make quite a difference to a picture. If you can, take time to move around, checking different angles through your viewfinder, before pressing the shutter.

When framing your picture, you may be concentrating so much on the main subject that you do not notice all the other things in the picture. The resulting print may be disappointing because there are too many other bits and pieces to catch the eye. Too much clutter in the background or foreground can be an unwelcome distraction. This is another reason for taking time to get it just right.

BY MOVING AROUND AND CHANGING YOUR ANGLE OF VIEW, YOU CAN DRAMATICALLY ALTER THE COMPOSITION OF A PICTURE.

Light

Most of the pictures in this book were taken in available light – that is without the use of flash or artificial lights, just making use of the light that was there, even indoors.

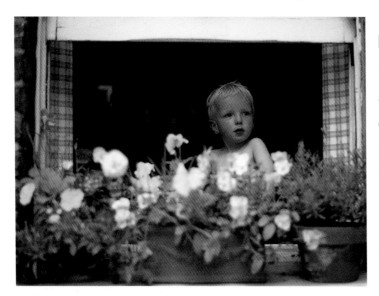

NATURAL DAYLIGHT ILLUMINATES A FACE AT A WINDOW, WHILE THE ROOM BEYOND REMAINS DARK.

Throughout the day, the light constantly changes, indoors and out, and the same subject can appear dramatically different when photographed at various times. Many people think that the middle of the day, when the sun is at its highest and brightest, is the best time to take pictures. However, when the sun is high the light can be harsh, causing unflattering shadows. If your subject is placed directly facing the sun, it can cause him to squint.

On a sunny day, wait for a cloud to pass in front of the sun, or move your subject into a shaded area, taking care that there are no hard shadows across his face. When photographing a scene or a stationary object, you may have to change your own position to make best use of the available light.

INDOOR LIGHTING CAN AFFECT COLOUR BUT PRODUCES SOME INTERESTING RESULTS.

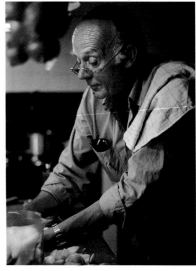

Flash

Cameras with built-in flash units often result in pictures of people with red eyes. This is because the light reflects off the retina at the back of the eye, which is red. The problem can be avoided by using a separate flash unit, or by asking your subject to look at a light, which will make the pupils smaller, before you take the picture. Some automatic cameras include a mechanism to help reduce this problem.

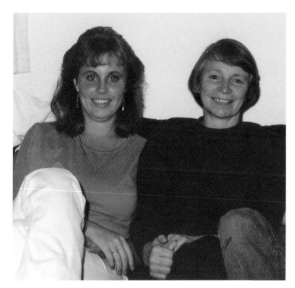

RED-EYE CAN RUIN AN OTHERWISE ACCEPTABLE PICTURE (ABOVE).

When you take a photograph of a group of people, make sure that everyone is positioned more or less at the same distance from the camera, or those in the foreground may be bleached out by the flash and those furthest away not illuminated at all.

INDOORS, AUTOMATIC FLASH CAN BE TOO BRIGHT, RESULTING IN BLEACHED-OUT FACES (ABOVE) WHILE OUTDOORS, IF THE SUBJECT IS TOO FAR AWAY, IT MAY NOT BE ILLUMINATED AT ALL (LEFT).

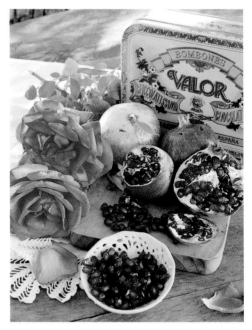

Colour

If you are taking pictures with colour film, look for colour in your compositions. This sounds obvious but how many times have you picked up your prints from the processors and been disappointed with dull results? Colour doesn't have to be bright to have impact: a landscape full of muted shades can be very atmospheric, for example. Do try, however, to look for colour when taking photographs and you will have some happy surprises when you collect your next batch of prints.

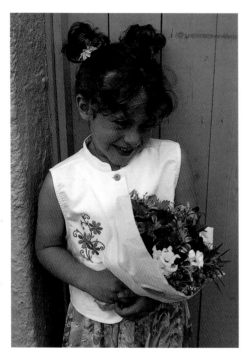

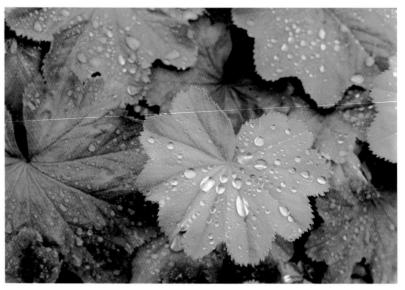

A CHILD HOLDING A COLOURFUL BUNCH OF FLOWERS, AND STANDING IN FRONT OF A PLAIN COLOURED BACKGROUND, RESULTS IN A VERY SUCCESSFUL PORTRAIT (ABOVE).

A CLOSE-UP OF DEWDROPS ON ALCHEMILLA MOLLIS LEAVES SHOWS HOW EFFECTIVE A SINGLE COLOUR CAN BE (RIGHT).

AN ARRANGEMENT OF FLOWERS AND POMEGRANATES ON A TABLE IN A GARDEN MAKES A PRETTY STILL LIFE (ABOVE RIGHT).

Portraits

Most of us use our cameras to take pictures of people. Instead of just pointing your camera and asking your victim to say 'cheese', there are a few tricks you can employ to produce more pleasing, natural portraits.

Your subjects will usually be aware that you are taking the picture but sometimes they will not. Even if they are conscious of being photographed you can still produce a picture in which they look relaxed. Many of us feel quite self-conscious when having a photograph taken but you should remind your victims that if they relax they are far more likely to end up with a pleasing result than if they are reluctant or even hostile to the photographer!

When taking pictures of children, instead of always making them look straight at the camera, stay on the sidelines some-times and observe them at play. By being inconspicuous, you have a better chance of trying to capture their various moods.

IF YOUR SUBJECT IS SHY, ASK THEM TO LOOK AWAY FROM THE CAMERA INSTEAD OF DIRECTLY INTO THE LENS (ABOVE).

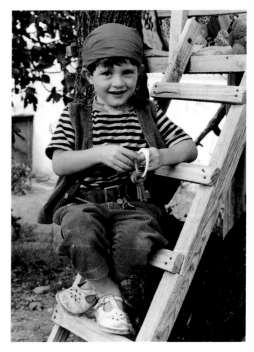

TO PRODUCE SEMI-FORMAL PORTRAITS OF CHILDREN, GET THEM TO SIT DOWN FOR A MOMENT AND GIVE THEM SOMETHING TO OCCUPY THEIR HANDS (ABOVE) OR ALLOW THEM TO PULL FUNNY FACES (BELOW, LEFT).

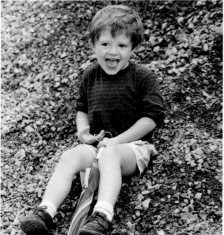

Photographing two people together can produce excellent results, especially if you can show the relationship between them. Instead of looking at the camera, they could try looking at each other, or both look at another object such as a book, or something in the distance.

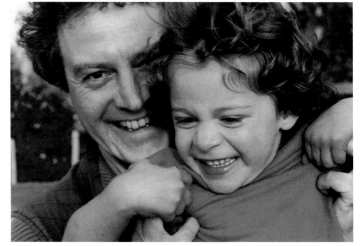

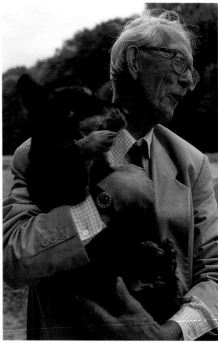

DOUBLE PORTRAITS CAN BE VERY SUCCESSFUL, WHETHER A MAN AND HIS DOG (ABOVE), A FATHER AND CHILD (ABOVE, RIGHT) OR TWO BEST FRIENDS (RIGHT).

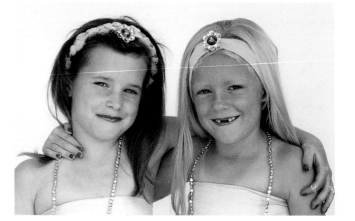

WHEN THERE ARE EIGHT PEOPLE TO PHOTOGRAPH (BELOW) IT'S HARD TO GET THEM ALL TO LOOK AT THE CAMERA.

Group photographs can be tricky. Even if the majority of the subjects are smiling or looking relaxed, there will be one or two people blinking or pulling a face. The best advice in these circumstances is to shoot as many frames as you can in the hope that, in at least one shot, everyone will look good.

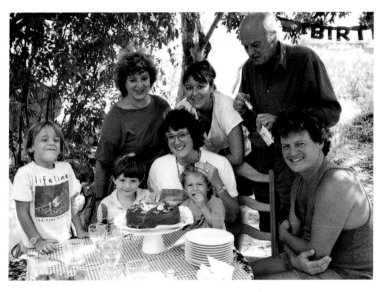

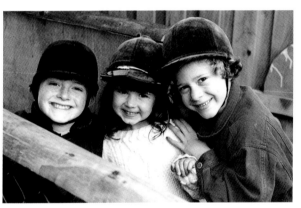

Out of doors, try to take people pictures in soft daylight, without the harsh shadows produced by bright sun. Indoors, to take advantage of natural light and avoid the use of flash, position your subject near a window or door.

SOME CHILDREN ARE NATURAL MODELS (LEFT) – BUT WITH A LITTLE CO-OPERATION, YOU CAN GET THREE CHILDREN TO SMILE AT THE SAME TIME (ABOVE, RIGHT).

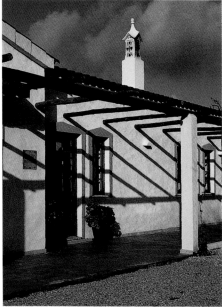

IN BRIGHT SUN, SHADOWS CAN CREATE A MARVELLOUS PATTERN (ABOVE).

Landscapes

A wide-angle lens is a good choice for landscapes, so a compact camera, which often comes fitted with a wide-angled lens, can usually produce satisfactory results.

Instead of always waiting for a sunny day, look out for the effects of different light and weather conditions on the landscape. Sunshine will give strong colour contrasts and dramatic shadows; mist or haze can create subtlety and a sense of mystery, while a blanket of snow or an expanse of sand can produce some marvellous shapes and textures.

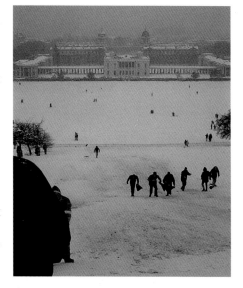

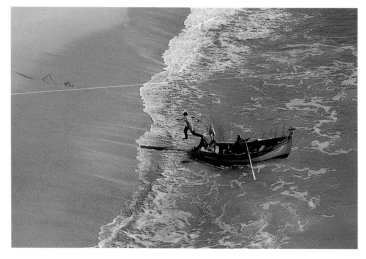

SNOW CAN REALLY ALTER A FAMILIAR LANDSCAPE ABOVE), WHILE THE SEA, EVER-CHANGING, HAS A WONDERFUL RANGE OF COLOURS, SHAPES AND MOVEMENT.

Holidays

On holiday, try to capture details as well as the wider scene. If your usual batch of holiday snaps comprises beach scenes

and pictures of friends and family in their swimsuits, next time you take your camera on holiday, try to capture something different: a pile of colourful peppers on a market stall, a menu board, an interesting doorway or piece of architecture, or even washing hanging out to dry.

Once again, don't rely on the sun. If you take your camera with you on a walk at dusk you may be able to capture a dramatic sunset or cloud formation. To create an interesting skyline, keep the horizon low in the frame, to eliminate distracting details.

BY WANDERING OFF THE BEATEN TRACK, YOU MAY FIND RICH AND VARIED SUBJECT MATTER FOR YOUR PHOTOGRAPHS (ABOVE).

AN INTERESTING DOORWAY (ABOVE) AND AN EXOTIC SUNSET (LEFT) ARE CLASSIC HOLIDAY SHOTS, EASY TO ACHIEVE.

Print Formats

The standard size of print from a 35mm film is 15cm x 10cm (6in x 4in). Some photo labs offer larger prints , usually costing a little bit extra, or a range of different size enlargements printed from your negatives.

Some processors offer passport-sized prints, contact sheets – all the pictures from one film, printed in miniature on a single sheet – or combinations of large and small prints, the larger one for framing or sticking in an album, the smaller ones just the right size for carrying in your wallet.

If you are particularly pleased with a picture but not quite happy with the composition, it may be worth having a selective enlargement made, where you ask the printer to print only a selected portion of the negative. Alternatively, you could have a straightforward enlargement made and cut out the best part of the picture.

When choosing pictures to make up into the projects in this book, it is useful to make yourself a pair of 'croppers'. These are two L-shaped pieces of cardboard which you place on your print to frame a certain area and then move around to help you decide which parts of the picture could be trimmed off to improve the overall composition.

TO HELP YOU SELECT AREAS TO BE CUT AWAY, MAKE A PAIR OF 'CROPPERS' FROM OFFCUTS OF BLACK CARDBOARD (RIGHT).

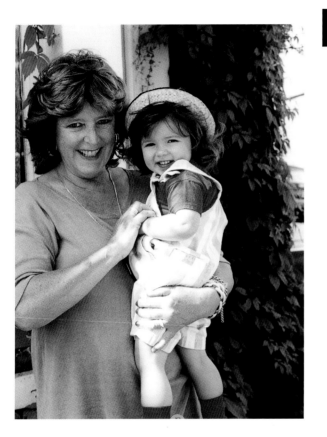

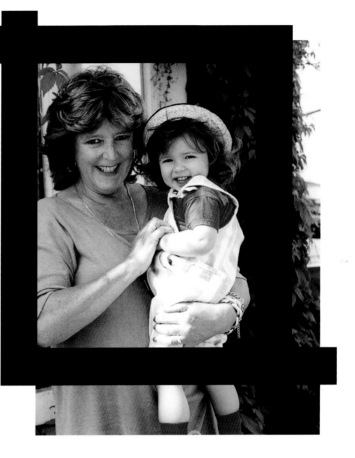

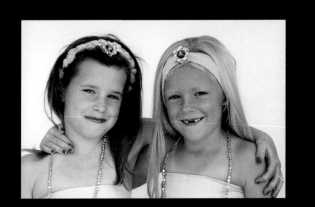

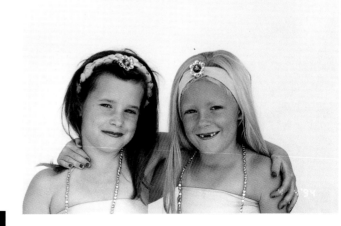

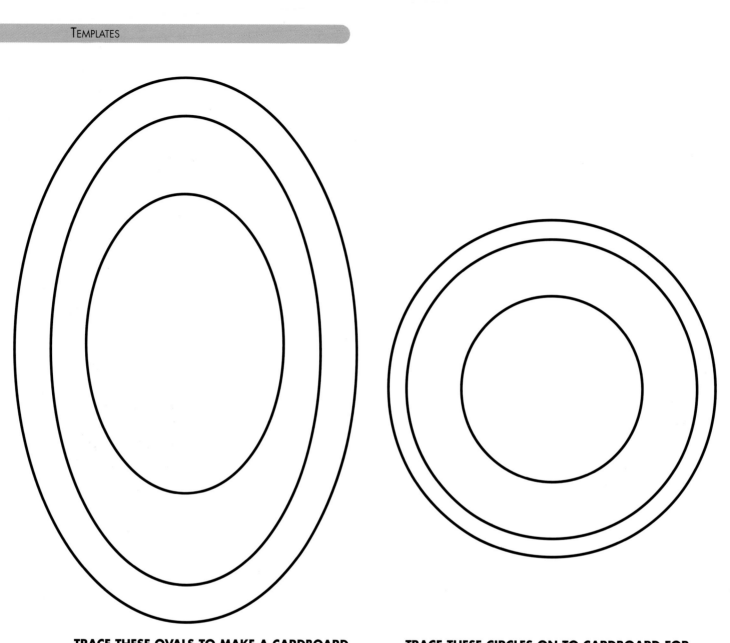

TRACE THESE OVALS TO MAKE A CARDBOARD MOUNT FOR THE FABRIC FRAMES ON PAGE 50.

TRACE THESE CIRCLES ON TO CARDBOARD FOR SOME OF THE DECORATIVE MOUNTS ON PAGE 46.

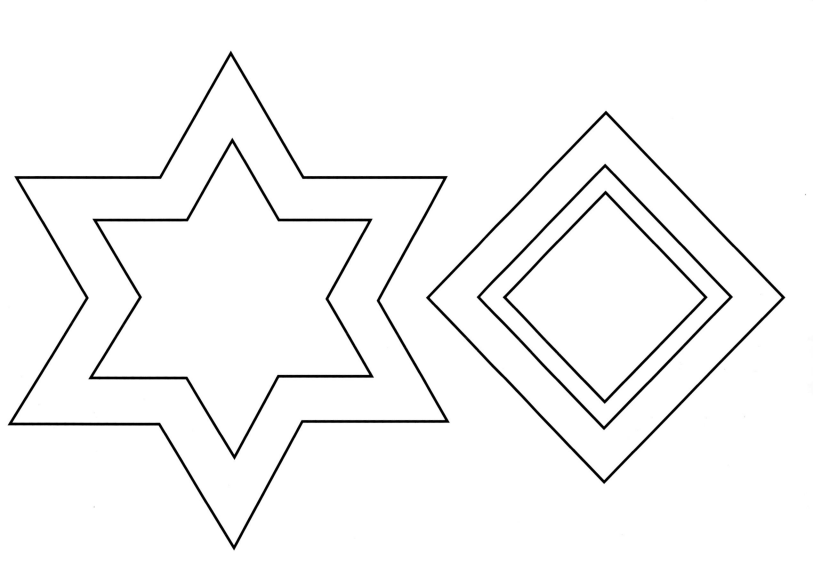

TRACE THESE STAR SHAPES ON TO THICK CARDBOARD, TO USE AS TEMPLATES FOR THE STAR DECORATIONS ON PAGE 102.

USE THESE SHAPES AS TEMPLATES FOR SQUARE OR DIAMOND-SHAPED CARDBOARD MOUNTS FOR THE PROJECTS ON PAGE 46.

ANNE BRINKLEY DESIGNS
12 Chestnut Hill Lane
Lincroft NJ 07738
**Silver and gilt display boxes,
acetate blanks and frames**
(Wholesale suppliers only)

BINNEY & SMITH US
1100 Church Lane, PO Box 431
Easton PA 18044-0431
Tel: 610 253 6272
Liquitex paints

COLART AMERICAS INC
11 Constitution Avenue, PO Box 1396
Piscataway NJ 08855-1396
Tel: 908 562 0770
Lefranc & Bourgeois paints

CRAFT CREATIONS
Ingersoll House, Delamare Road
Cheshunt, Herts EN8 9ND
UK
Tel: +44 1992 781900
Greetings card blanks

FUJI PHOTO FILM USA INC
555 Taxter Road
Elmsford NY 10523
Tel: 914 789 8100
**Advance Photo System
Cameras and film**

GAY BOWLS SALES INC
PO Box 1060
Janesville WI 53547
**Silver and gilt display boxes,
acetate blanks and frames**
(Wholesale suppliers only)

LATHAM STUDIOS INC
405 West Franklin Street
Baltimore MD 21201-1800
Tel: 410 727 7333
Magic Dip marbling kits

MANCO INC
31250 Just Imagine Drive
Avon OH 44011
Tel: 440 937 7000
UHU adhesives

PEBEO OF AMERICA
1905 Roy Street
Sherbrook, Quebec J1K 2X5
CANADA
Craft paints
(Wholesale suppliers only)

PENNY BLACK
PO Box 11496
Berkeley CA 94712
Tel: 510 849 1883
Rubber stamps

POLAROID CORPORATION
575 Technology Square
Boston MA 02839
Tel: 617 577 2000
Polaroid instant cameras and film

PRYM-DRITZ CORPORATION
PO Box 5028
Spartanburg SC 29304
Tel: 864 576 5050
Dylon Image Maker

SANDYLION
400 Cochrane Drive
Markham, Ontario L3R 8E3
CANADA
Tel: 905 475 0523
Sandylion stickers

SPECIALIST CRAFTS LTD
Export Department
PO Box 247, Leicester LE1 9QS
UK
Export Fax: +44 116 262 6162
Web site: www.speccrafts.demon.co.uk
**For a wide range of craft materials,
including some hard-to-get items**

3M COMPANY
3M Centre
St Paul MN 55144-1000
Tel: 612 733 1110
Spray adhesives

ACKNOWLEDGEMENTS

THE AUTHOR WOULD LIKE TO GIVE SPECIAL THANKS TO THE FOLLOWING PEOPLE:

Liz and Pleun at Laura Ashley, for providing fabrics; Carol Hook at Clear Communications for keeping me well stocked with Pébéo paints; Pat Wallace at Polaroid; Steve Waldron at Fuji; Anthony Ward at Bonusprint, and Jon Madeley at Scumble Goosie.

Des Curran, for working with such devotion on the design and production of the book, and Sheila Murphy at Aurum Press for having the faith to do it in the first place. Thanks, too, to Amanda, Di and Edward, for photographing the finished projects.

Ann Coppinger, and my parents, Valerie and Peter Johns, for providing some of the photographs used.

My family and friends who acted as models – particularly Elsa and Solange in Portugal, and my children, Joshua, Lillie and Edith.

My father, who is a professional photographer and a truly great artist, and my mother who has such a marvellous sense of style, for being such an inspiration to me. Not forgetting my husband, Tom who, by sharing my life, allows me to pursue my career with a passion.